AN ILLUSTRATED GUIDE TO
MAORI ART

Dr Terence Barrow, an acknowledged authority on
Maori art, has made many original contributions
to the subject.

He was born in New Zealand and in 1949 joined
the staff of the Dominion Museum (now the
National Museum of New Zealand), Wellington, as
an assistant in the ethnology section. When the
senior ethnologist, W.J. Phillipps, retired in 1957
Dr Barrow succeeded him as the curator of Maori
and other Pacific collections. In 1965 he accepted
a related position at the Bernice P. Bishop Museum
where Hawaiian cultural materials were a central
responsibility.

Terence Barrow graduated B.A., University of
Auckland; M.A., Victoria University, Wellington;
and Ph.D., University of Cambridge, England.
Over the years he has known the great figures in
Pacific museum studies, the private collectors, and
of course many Maori craftsmen, such as Pine
Taiapa to whom he has dedicated this book.

Dr Barrow lives in Honolulu, Hawaii, with his
wife and two sons.

Cover illustration

An early nineteenth-century ancestral image 64 cm high, being
the base part of a house ridge support post (poutokomanawa).
The art style indicates an East Coast (North Island) origin.
Collection of the Peabody Museum of Archaeology and
Ethnology, Harvard University, Cambridge (U.S.A.) Museum
records are that this carving was probably deposited by Thomas
Jefferson, America's third president, who died in 1826.

AN ILLUSTRATED GUIDE TO
MAORI ART

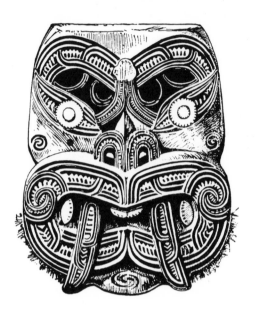

TERENCE BARROW

REED METHUEN

By the same author:

Decorative Arts of the New Zealand Maori (1964)
Traditional and Modern Music of the Maori (1965)
Women of Polynesia (1967)
Maori Wood Sculpture of New Zealand (1969)
Art and Life in Polynesia (1972)
Incredible Hawaii (1974)
Captain Cook in Hawaii (1976)
Maori Art of New Zealand (1978)
The Art of Tahiti and Neighbouring Society,
 Austral and Cook Islands (1978)

Title page illustration

A nineteenth-century house gable mask, Bay of Plenty, drawn by British Museum artist C.M. Praetorius. From *Studio* magazine, October 1900.

Copyright©Terence Barrow 1984

First published in 1984 by
Methuen Publications (NZ) Ltd,
Auckland, New Zealand

Reprinted 1986 by
Reed Methuen Publishers Ltd,
39 Rawene Road, Auckland 10

ISBN 0 474 00171 7

Design and production by Richard King and Jane Connor

Typeset by Artspec·Typesetting Systems Ltd

Printed in Hong Kong
through Bookprint Consultants, Wellington.

Dedicated to the memory of
PINE TAIAPA
(b. 1901, d. 1972)

PINE TAIAPA, master carver, teacher and friend of so many, came from the Ngati Porou tribe of New Zealand's East Coast — a people long renowned for their carving skill. He extended their long tradition and revived it by bringing back the craft of adze work, which had, before this time, given way to mallet and chisel. Many carved ceremonial meeting houses were made under his direction by men who followed him as their tohunga whakairo. I met Pine many years ago when he was the senior Maori carver demonstrating his art in the Maori Court of the Centennial Exhibition, which opened at Lyall Bay, Wellington, in 1940. In later years it was one of the great privileges of my life, as a student of Maori art, to be a guest in his home at Tikitiki.

CONTENTS

ACKNOWLEDGEMENTS

The first acknowledgements are due to the craftsmen and craftswomen who created the objects illustrated and explained in this book. These people of skill and accomplishment have long departed this world for Reinga — Land of the Spirits. Haere, Haere, Haere ki te Po! Old teachers have also passed to another world — Pine Taiapa, Te Rangi Hiroa (Sir Peter Buck), H.D. Skinner, Roger Duff, W.J. Phillipps and Elsdon Best. Their contributions to Maori studies were immense, and I extend my thanks to all of them. I owe a particular debt to three private collectors of artefacts, now deceased, whom I knew in England in the 1950s: K.A. Webster, Captain A.W.F. Fuller and James Hooper. One could not have wished for more generous and hospitable people.

However, acknowledgements in books are mostly concerned with the living, so I shall now mention those who helped directly with this particular book which was written under difficult circumstances, since I am a resident of Hawaii able to make only brief annual visits to my home country of New Zealand. For the most part I have written the book from accumulated experience of past years as a museum curator at the Dominion Museum (now National Museum of New Zealand). I have also used such books and archival resources as are available in Honolulu. The new materials incorporated in this book were gathered on New Zealand visits in late 1981 and early 1983. I concentrated, in the time available on these 'vacations', on the National Museum of New Zealand in Wellington, the Auckland Institute and Museum, and the Hawke's Bay Museum.

At the National Museum of New Zealand my old friend Dr J.C. Yaldwyn made collections and facilities for photography available, and I was welcomed and helped by staff members — notably Mrs Betty McFadgen, Curator of Ethnology; R. Neich, Ethnologist; R.B. O'Rourke, Technical Officer; and Warwick N. Wilson, Senior Photographer, who not only set me up for photographic work, but produced colour transparencies of a number of items (these are noted in the Photo Credits). Roger Neich provided invaluable help in reading the manuscript and printer's proofs of this book, and he made many helpful suggestions and corrections.

At the Auckland Museum I was hospitably received by Mr. Stuart Park, Director, and my old friend and colleague D.R. Simmons, Assistant Director and Ethnologist. Nothing was spared to see that I secured the photographs and reference materials I wanted. Dr R.B. McGregor, Director of the Hawke's Bay Art Gallery and Museum, Napier, was most obliging in allowing me access to the fine collection of Major General Horatio Robley's watercolours.

General acknowledgements must be made to the trustees, directors and staff members of the various museums noted for permission to

photograph and study Maori objects and, in some instances, to secure museum prints of them. To attempt to name the many individuals in a dozen or more countries who have helped me over some decades would be out of place here. All I can say is that I am most grateful for the friendly help I have received.

To conclude these acknowledgements, I wish to mention certain individuals who helped substantially in making this book possible. They provided me with 'base camp' accommodation in their homes, local transportation, and the spiritual warmth of welcome and unstinting hospitality. I would be lacking in courtesy if I failed to mention Mr and Mrs Ernie Conaghan of Milford, Auckland; Mr and Mrs G.W. Barrow of Wainuiomata, Wellington; and Mr and Mrs Peter Bolland of Napier. My friend of several decades, Ray Richards of the Richards Literary Agency, went beyond the call of duty as my agent in providing me with transportation and (with Mrs Richards) friendly hospitality. To write an illustrated guide of this kind is far from easy, and I must note that Ray Richards did much to smooth the path. Also I am thankful for the patience and help of the editorial and design staff of Methuen New Zealand.

<div style="text-align: right">

Terence Barrow
Honolulu, Hawaii

</div>

PHOTOGRAPHIC CREDITS

Most of the illustrations in this book, whether photographs of actual objects, copies of historic prints, or line drawings, are the work of the author so need no specific mention here. Warwick Wilson, Senior Photographer, National Museum of New Zealand, kindly provided colour transparency materials for tukutuku panels and the Angas lithographic plates. A few of the older prints obtained many years ago lack documentation. If any reader can provide the publisher with any information that should be recorded, it would be much appreciated.

The source of particular illustrations is here acknowledged with credit to the following institutions:

Alexander Turnbull Library pages 13, 66
Auckland City Art Gallery pages 11, 15, 76, 79
Auckland Institute and Museum pages 25, 29, 42
 colour plates facing page 65
Hawke's Bay Museum pages 16, 21
National Museum of New Zealand pages 20, 22, 26, 27, 28, 37, 48, 66, 68, 69, 88, colour plates facing page 33
New Zealand Tourist and Publicity Studio page 47
University Museum, Philadelphia, U.S.A. page 60

INTRODUCTION

This book is an illustrated guide to the visual arts of the Maori as they existed from about the time of Captain Cook's landing on New Zealand shores in 1769, until about 1900 the so-called Classic and Historic periods.

The illustrations, captions, and comments are aimed at helping people to appreciate the charm of Maori art and to look at its sculptural forms, patterns, and designs with perception. The Polynesian settlers of New Zealand, now called 'Maori', formerly referred to themselves only by their tribal or sub-tribal names. The word 'maori' means, as an adjective, 'normal, usual, ordinary, native to the place', as opposed to what is strange and foreign. Before 1850 the Maori people were called, by European writers, 'New Zealanders'. The arrival of European settlers — the Pakeha — gave need for a distinctive name for the Polynesian inhabitants of New Zealand.

The past tense is used when referring to the arts described because they are creations of former times. Many post-1900 objects are illustrated as an aid in explaining the earlier works. A number of the arts described are practised today but it must be recognised that old and new Maori arts are different in many ways. It is hoped that this book will help modern craftsworkers who utilise traditional Maori art symbols to use them with respect, understanding and good taste.

This book describes in a general way what are now called the 'visual arts' of the New Zealand Maori — that is those arts that we see with our eyes, and can touch with our hands. The verbal arts of song, chant, oratory and storytelling, and the arts of dance, are closely related yet ephemeral. They were perpetuated by generations of practitioners, but they had by their nature no 'tangible' substance. We know of their early forms from written descriptions, sketches by artists of the eighteenth and nineteenth centuries, and photographs from 1860 onward. The actual sounds and bodily movements could not be preserved like the artefacts made by the hands of the traditional Maori, which provide us with such an impressive contact with Maori past.

The first European descriptions of the Classic Maori were the sketches and journal entries of the expedition of the Dutch navigator Abel Tasman who, after crossing the sea later named after him, reached the South Island of New Zealand in 1642. He did not land but Maori warriors in canoes attacked his ship's boat killing four seamen. Tasman departed without setting foot on 'Staten Landt'.

The next European contact did not occur until 9 October 1769, when James Cook went ashore near the mouth of the Turanganui river, the site of the modern town of Gisborne. His small landing party was also attacked by warriors, but Cook's men fired muskets, killing several of the Maori. Weapons were collected from the bodies of the fallen as objects of curiosity, and so the study of Maori art began.

May I ask readers to accept this book as a general guide to Maori visual arts. It is not intended for experts, although some of its ideas might be helpful to them. There is no attempt to present a comprehensive description of Maori culture, yet many aspects of it are reviewed in order that the visual arts might be better understood.

A General Review of Maori Art

Classic Maori arts evolved from earlier models and artistic ideas. They are the products of a thousand years of Polynesian endeavour in New Zealand. The first human settlers came as canoe navigators to New Zealand's shores from the tropical islands of East Polynesia (Marquesas, Society, and Cook Islands). How many people or canoes were involved or when or where they landed is unknown. What is clear is that these pioneers brought with them a Neolithic Stone Age culture and a range of technological skills which had been developed in tropical climates and on relatively small islands. These skills were applied to the new materials available, and the culture adapted to the cool climate of New Zealand. The earliest settlers, whom we now call the Archaic or Moa-hunter Maori, were the forebears of the Classic Maori and there is a distinctive relationship between their respective arts.

The first meeting of Maori with European was a brief one, puzzling to both parties. In 1642 the Dutch maritime explorer, Abel Tasman, anchored in the Nelson bay now named Golden Bay. When Maori warriors attacked one of his ship's boats, killing four sailors, he sailed away to the north, traversing the west coast of the North Island and departing these seas at Three Kings Islands north of Cape Maria Van Diemen. The particular interest of this voyage is the illustrations that provide our first pictures of the Maori as seen through the eyes of seventeenth-century Dutchmen.

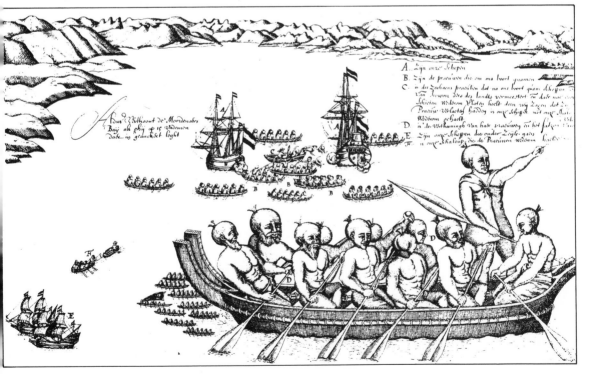

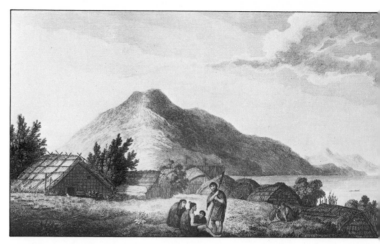

An engraving from a sketch by James Webber, artist with the Third Pacific Voyage of Captain Cook. This late 1770s scene shows a Maori group conversing inside a lightly fortified village in Ship Cove, Queen Charlotte Sound.

The first European encounters with the Maori, from Dutchman Abel Janszoon Tasman's 1642 visit to those of Captain James Cook and other mariners of the later half of the eighteenth century, were often violent with little or no verbal communication. After 1800 a mutual respect became established as the Maori realised the usefulness of western goods, and visitors became more appreciative of Maori culture and its arts. This 1830s scene shows men of the French corvette *L'Astrolabe*, under command of D'Urville, fraternising with Maori warriors before a house that lacks the elaborate carved fittings of later times.

The Archaic Maori found food by foraging, fishing and hunting. Gradually over the centuries the early New Zealanders came to rely more on the cultivation of gardens and in time became settled villagers, concentrated mostly about the warmer coastal regions of the North Island. In more stable economic and social conditions craftsmen and craftswomen had the chance to specialise in skills that became increasingly sophisticated. However, the conditions of regular village life associated with crop cultivation led to the need for rigid territorial claims. This fact and the steady increase in population led to social stresses which caused intensive intertribal conflict. The artistic products of Classic Maori art reflect social attitudes and economic developments in a most dramatic way.

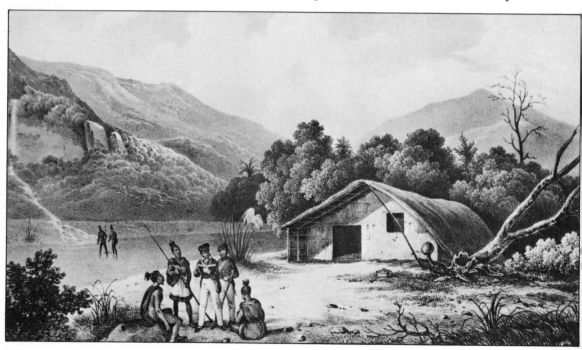

Classic Maori art is clearly an expression of a war-oriented society. Its warrior chiefs were glorified above all others in the community, and they were supplied with the best goods. To die in battle was the greatest glory, while the greatest shame was to be taken prisoner then made a slave. Death was considered far preferable to that degrading fate.

Maori Art and Society

To understand Maori visual art it is necessary to know the basic structure of Classic Maori society. We must comprehend the principles of social organisation and the role of crafts in relation to society.

In pre-European Maori tribal society the relationship of groups and individuals was based on blood kinship and marriage. The units that formed society consisted of the extended family or whanau — the simple man-woman-child family as we know it today just did not exist. The whanau was a cluster of closely related persons, including grandparents, parents, children, and spouses who came from related tribes or subtribes. A varying number of whanau grouped together to form a sub-tribe or hapu. Hapu were clustered to become a named tribe, called the iwi. Through connections over generations, each tribe had relationships with other tribes and thus retained a loose kinship. Prefixes were added to tribal names to indicate a tribe, e.g., 'Ngati' (Ngati Tuwharetoa), 'Ngai' (Ngaiterangi), 'Ati' (Ati Atiawa).

The word waka means 'canoe' or 'tribe' in the social sense of the word. The assumption that each tribe or related tribes had a common origin in the arrival of a particular canoe from a distant island home (Hawaiki) is disputed by some anthropologists. Some scholars are of the opinion that such 'canoes' were in reality tribal groups that made internal migrations within New Zealand. Regardless of such ideas, the Maori people hold firmly to their relationship to particular tribal canoes.

Classic Maori society was like a growing tree with a main trunk and branches large and small. Some tribes flourished and grew in power while others withered. Good or bad alliances, the fortunes or misfortunes of war, the vagaries of weather affecting sweet potato and other crops — every aspect of old-time Maori life was uncertain and hazardous.

The territories of tribes were more-or-less defined, yet land remained a cause for dispute and battle. Any insult placed an obligation on the group or person so affected to take revenge. That was the Maori law of utu.

The status of the individual in society was determined by both birth and sex. Those closest to the gods in the genealogical

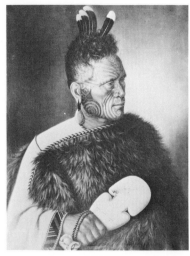

King Tawhiao, who was declared king of certain Maori tribes at the death of his father Te Wherowhero, was a participant in battles with the Europeans in the time of the New Zealand wars. He was born at Orongokoekoe about 1825 and died in 1894. Among the last of the truly old-time Maori, he was a man of dignity and impressive presence. This portrait of Tawhiao, wearing a kiwi-feather cloak, tail feathers of the huia, and holding a short club of kotiate type, is by Gottfried Lindauer and is in the Auckland City Art Gallery.

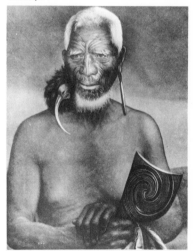

Portrait of the fighting chief Tukukino of the Ngati-Tamatera people. A commissioner of Maori affairs in his time described him as 'a pretty good fellow, but intensely obstinate'. In this portrait by Gottfried Lindauer, in the Auckland City Art Gallery, he is shown wearing in his ears the head and dried skin of a huia and a drop jade pendant. He is holding a long club of the tewhatewha type.

records were the first in rank as high nobles — the ariki. First born sons took hereditary precedence and inherited leadership. Ariki women possessed great prestige (mana), yet the general restrictions on women greatly limited their role in society. Many activities and foods were denied females. Of course men or women of exceptional ability surmounted the shortcomings of birth. Maori society was a vigorous one that recognised merit in individual persons in any circumstances.

Below the divine ariki were chiefs of differing ranks — rangatira — and below them were the mass of commoners — tutua — who formed the main body of society. No person liked to think of himself as being of a low degree. It seems that everyone found some link to a person of rank.

A despised group of people — the taurekareka — were slaves without class designation or rights. They originated as prisoners of war, being those men, women, and children who had been allowed to survive after capture so that they could be put to

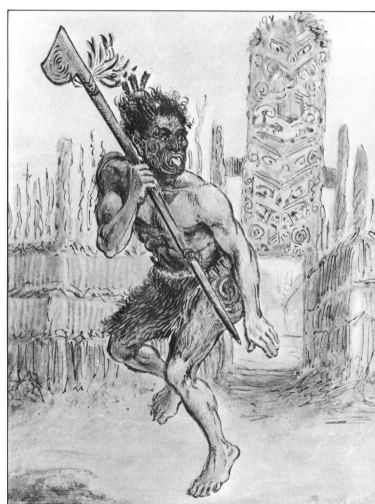

Major General Horatio Robley, who became a notable student of Maori tattoo, was well familiar with the warriors of the late nineteenth century. This sketch from the collection of the Hawke's Bay Museum, Napier, depicts a prancing chief in an attitude of challenge before the Maketu Pa, Bay of Plenty.

ork. They had no rank, and their children were not born free unless their other parent was a freeborn man or woman. Slaves generally were kindly treated, yet they were hard worked and also were drawn upon when human sacrifices were needed, or as food to be baked in the earth oven. The celebration of an important occasion, such as the visit of a special guest, required the relish of human flesh.

Young men and women married within their rank. Several wives or even several husbands were allowed to those who were worthy and able to support them. Children ran free until adolescence, until the cares of adulthood fell upon them. The young were regarded as tribal property. Any accidental injury the child suffered brought vengeance on the heads of the nearest kin in the form of a ritual raiding party (muru).

Each phase of life had its rites, their importance being related to the rank of the individual. Children were dedicated to one or another deity; if the individual was to follow the art of war, to Tu, the god of war; or to Rongo, the god of peace and fertility, and so to the arts of peace. Scholarly houses of learning existed in which a chosen few learned sacred lore.

The Maori attitude toward property was unlike that of modern man. Tribal lands, houses, canoes, and similar large possessions were the common property of the sub-tribe or tribe. Personal possessions were limited to a few ornaments, clothes, weapons, and other articles used by individuals in life.

The chiefly classes, both ariki and rangatira, commanded the best craftworkers and their products. They were often skilled craftworkers in their own right. Maori art was aimed primarily at serving the needs of chiefly persons. The finest cloaks, ornaments, weapons, decorated houses, and household paraphernalia helped give dignity to the life and appearance of highborn individuals. The mass of commoners possessed few fine objects that we categorise as 'art'.

It was believed that all knowledge was of divine origin, a gift from the great god Tane, who gave mankind three baskets of knowledge — Nga Kete-o-te-Wananga. These baskets contained accounts of creation, instructions on magic (both black and white), and similar information. The individual crafts, themselves, were each of supernatural origin, being secured either from the heavens or from the underworld.

The practitioners of crafts were usually men of rank. Some were the tohunga or priestly specialists who were selected by birth and aptitude. Commoners who showed special talent could become respected artists, yet the majority engaged in sacred craft work were of high rank.

Craft experts of various callings, such as the woodcarver (tohunga whakairo) or the tattooer (tohunga-ta-moko), were paid for their services in goods, food, and tribal hospitality.

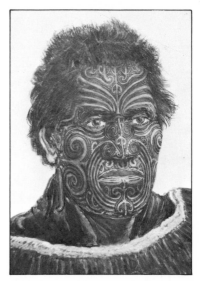

Robley's watercolour portrait of the noted Maori carver and warrior Te Kuha of the Ngai Terangi people, Bay of Plenty. Te Kuha fought in the 1860s in campaigns of the New Zealand Wars, an epoch of Maori-Pakeha conflict formerly called 'the Maori Wars'.

Prior to the coming of the European, the Maori had neither currency nor any set rate of payment for work done. However, generosity was the mark of a noble chief in a world where meanness was a despised shortcoming.

The sexual division of men and women in craft work was determined by certain beliefs concerning their basic differences. Women worked soft materials, such as flax fibre, in garment making and the weaving of mats and baskets, while men, who possessed greater physical strength, worked the hard material of wood, bone, and stone. Within this sexual division of labour there was a further separation based on rank.

The disassociation of male and female in almost every craft activity was due to traditional ideas about a fundamental difference in the nature of men and women. It was believed that men were directly descended from the gods and, as such, of sacred power. Women, in contrast, were of the earth and of common substance. Men were thus considered sacred (tapu) while women were non-sacred (noa). Thus, the affairs of the gods and ancestral spirits were the concern of men; the affairs of the earth were the concern of women. Such notions were not held in a prejudicial way. They were simply accepted as being the natural order of life.

The effect of this on art production was that women were excluded from the practice of carving and certain other crafts and were not permitted in the vicinity of men working in arts. Any breach of protective prohibitions (tapu) brought quick

The Classic Maori performed vigorous dances as expressions of defiance, as acts of welcome, and to entertain. Early artists' sketches, made long before the invention of photography, are valuable records in this and other areas of Maori life and art. This study by Augustus Earle, who was in North Auckland in the late 1820s, is entitled 'A Dance of New Zealanders'.

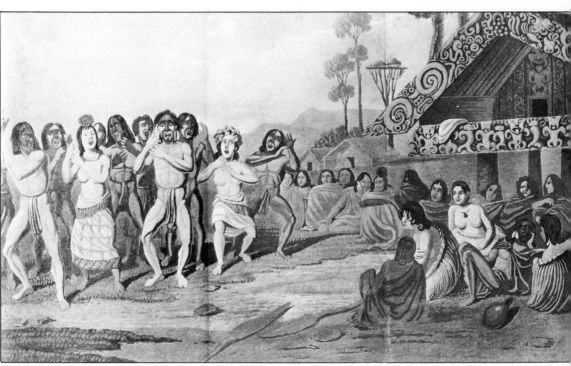

etribution, if not from the gods, then from man. A serious offence brought sudden death.

There was nothing demeaning about a noble person, man or woman, working in certain crafts. Indeed it was expected that a chiefly persons be expert in some creative activity. The rule was that persons of the same sex and similar social standing should work together.

The daily toil assigned to the majority of women was that of gathering firewood, fetching water (often from long distances), weeding cultivations, foraging forests, streams, and shores for wild foods, and doing the household chores. Most men laboured at fishing, fowling, building houses, erecting or repairing fortifications, and other heavy work. Every man could rough out an adze or bowl, while every woman could quickly plait a flax basket or mat, but the special art fields were the concern of well-trained persons. Elaborate Maori art objects were the work of experts and were made for the enhancement of communal pride or the aggrandisement of well-born individuals. Old Maori society was not democratic, nor were its visual arts. Of course, all enjoyed the pride of owning, as a tribe, or sub-tribe, fine canoes, storehouses, and other communal properties.

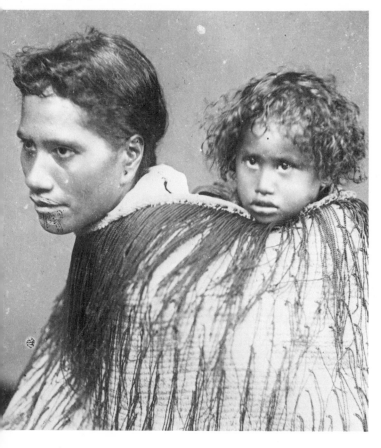

The traditional manner of a Maori mother carrying a child on her back under a blanket was a favoured subject of nineteenth-century painters and photographers.

19

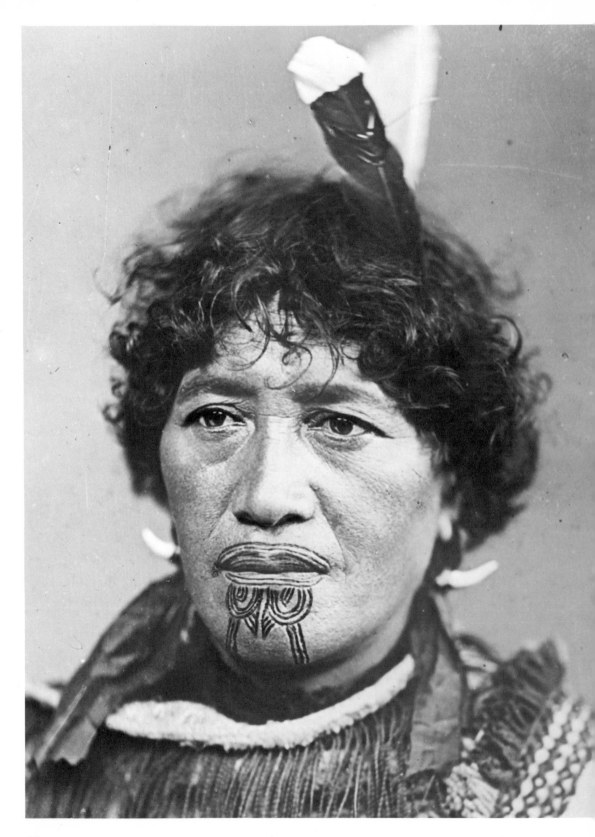

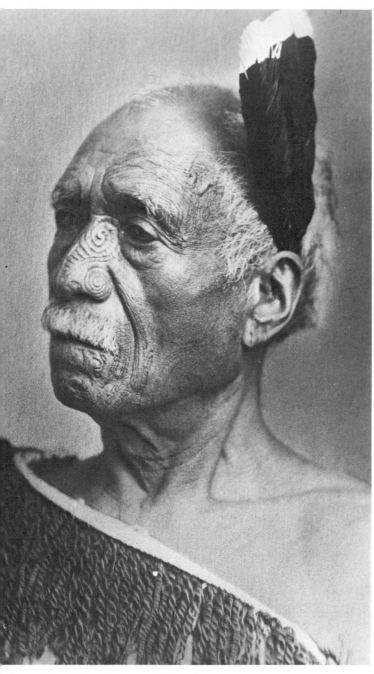

Portrait of the dignified elderly chief Hirawanu. In the latter years of the nineteenth century, with the general acceptance of Christianity, tattoo became a forbidden art. Men with tattoo, it would seem, made some effort to cover it with the facial hair formerly plucked away. Hirawanu wears a moustache. The white-tipped tail feathers worn behind his ear are those of the huia,. a bird that once flourished in southern North Island forests.

Opposite: A photographic study of a Maori woman named Hanatiri Te Rangi Tuatera, of Rotorua. She has a typical lip and chin tattoo. Photography became popular in New Zealand in the later decades of the nineteenth century, with the Maori as a subject gaining a wide public appeal.

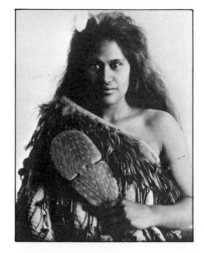 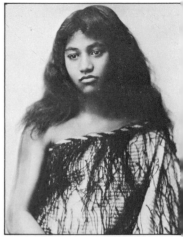

Both these studies are by the photographer Arthur Iles, who had a studio in Thames, then in Rotorua.

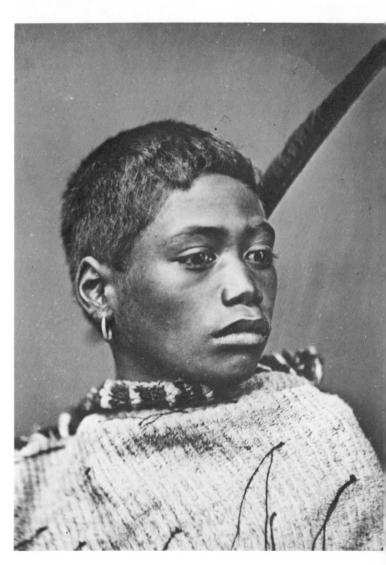

Study of a young boy with distinctive Maori facial features. The photograph was taken in the 1860s by the American Photo Company.

Characteristics of Maori Art

Maori art in its classic forms evolved over centuries of endeavour and craft experimentation. Some of its designs, motifs, and patterns have their roots in the distant homelands in South-east Asia and coastal China. Over millennia the Maori forebears had expressed religious and artistic ideas in wood, stone, bone, ivory, and other materials found in the prevailing environment. Tools were made of natural materials that could cut, such as stone, bone, shell, obsidian, and shark teeth.

A characteristic of all Polynesian art workmanship, including that of the New Zealand Maori, was the preference for making an object from a single piece of material — such as a block of wood — rather than joining one piece to another. However, architectural structures and large canoes were made of parts lashed together with fibre cordage. But even these things were composed of single, large pieces of artwork tied together. Each part was, technically speaking, made separately as an object in and of itself. In this sense each part of a canoe or house was an artistic object in its own right but joined to form the large structures. Communal effort, with parts carved by different craftsmen, was typical.

All Maori objects were made to serve a practical or symbolic function. They served a need in the everyday world of work — fish hooks, adzes, digging sticks — or as religious ritual items considered necessary to achieve some satisfactory result. Godsticks and crop gods are examples of this latter principle. Utilitarian artefacts often had ritual versions for ceremonial use. Examples of this were the elaborated digging sticks and fish hooks. Features added to objects of practical use, such as small figures or heads added to weapons, seem to be related to magic in aiding the power (mana) of the object and so improving its efficiency.

All man-made things had a spirit life and were not regarded by the Maori as inanimate 'dead' objects, as we now regard a bowl or spade. The importance of magic, such as might be effected by a post or panel representing an ancestor, did not interfere with the strength or practical utility of the carving. Ancestral figures were adapted to posts, panels, and other things in a manner that retained artistic design, without detracting from the primary utility of the object concerned.

Maori craftwork had a marvellous integration of function and form. Ingenuity in adapting motifs to the objects made can be seen in almost every decorated artefact. The rule was utility first, decoration second. When we use the word 'decoration', however, we must always bear in mind that carved symbols usually had magical functions. Ornateness no doubt pleased the eye of the traditional Maori just as it pleases us

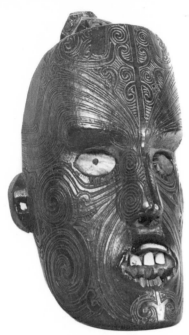

The sculptural dynamism of early woodcarving, in particular, is expressed in this head with inlaid incisor teeth, shell eye inlay and hair as eyelashes. Obviously of eighteenth-century origin, it is in the collection of the Museum of Mankind, British Museum, London. It is 29.5 cm high. According to Museum records, it was presented to the British Museum by New Zealand's first Governor General, Sir George Grey. The use of such heads is uncertain but, as some have a hole for a pole at the base, it is likely they were erected as warning markers (rahui) to indicate territorial limits. Some heads of this general type were fixed below the prow of war canoes.

today, yet to the makers and users, the objects and symbols were more than things of art.

The sturdy post figures (poutokomanawa) that held up the massive ridge-beam of a house were designed to withstand very heavy loads. Ancestral side panels (poupou) were also planned to support weight from heavy rafters that thrust downwards from the ridge-beam. All were parts of the body of the ancestor whose spiritual power held up the constructed house.

The physical size of Maori art works ranged from the very small to the very large — from hei-tiki the size of a thumb to war canoes over thirty metres in length. Regardless of the dimensions, the utility of design was always given priority over decoration. Furthermore, the material — wood, stone, or bone — was worked with a sensitivity that brought out its inherent qualities. The raw substance was not 'forced' to perform in a manner contrary to its nature.

Secondary decoration was applied where it seemed appropriate. Various sculptural forms were allowed to emerge. For example, jade, which is harder than most metals, was fashioned only by a grinding process, which gave rise to its particular simple shapes. Thus materials determined, to a great degree, the form of the sculpture. Hardwoods, such as those used in weapons, likewise were worked as the material dictated. In contrast, softwoods invited elaboration and, as a result, sculptural forms utilising such woods are inclined to be surface-decorated with involved designs and patterns.

The bad design of much modern work is in part due to the artists' use of tools which can force a material into shapes that are contrary to its natural qualities. The traditional Maori did not work that way. After the mid-nineteenth century when Maori woodcarvers acquired a variety of European metal tools, they lost this special sensitivity to materials that had been possessed by their forebears. Consequently, their artistic standards deteriorated. However, it is unjust to compare the craftsmanship of the Stone Age Maori with that of the post-Pakeha Maori. The changes in tools, religion, social conditions, and community attitudes that occurred are just too great.

The consistently high standards of pre-European-contact art were due to the clear-minded confidence, professional training, community needs, and critical attitudes of a Stone Age tribal society. The lowered standard of so much later nineteenth-century Maori craftsmanship was inevitable due to the changing times. Much nineteenth-century work is innovative and vital in conception. At its worst, it can be poor. A large proportion of pieces of Maori art in museums and private collections is of nineteenth-century creation, and in fact, the products of that century are generally regarded as typical 'Maori art'.

Definition of Terms

When we read about art and look at associated illustration we should know what the writer means when he uses certain words. This is particularly true in Maori art studies. The terms used in this book are defined as follows:

Design refers to an object conceived as an integrated whole, that is, with all of its individual parts unified. For example, the 'design' of a carved house includes all of its parts: panels, posts, facade boards, lintel, and so on. Likewise, the design of a war canoe is made up of a dugout hull, prow and stern parts, top-strakes, paddles, and other fittings. The parts in themselves have their own individual design.

A *symbol* is a dominant theme. It may be an ancestral image, a lizard, a whale, or an imaginary element which is of an abstract nature.

A *motif* relates to smaller units of a design.

Patterns are created by the repetition of a symbol or motif. Decorative elements used in the triangle arrangements of taniko cloak borders or in lattice panel work form distinctive patterns set on flat or curved surfaces. Patterns can also be seen in facial tattoo markings.

Some patterns emerged from technical processes. When mats were plaited from natural bleached and black-dyed flax strips, patterns appeared of themselves, although plaited patterns were planned to form certain designs. Those that resembled a natural or fanciful object were given appropriate names. These principles also apply to stitched panel work, e.g., the pattern formed from X stitches was likened to stars (whetu) in one design.

Style refers to the manner in which an art work was executed. District characteristics and the individual craftworker's particular way of conceiving a subject and handling his tools and materials resulted in a distinctive style. The involvement of individual artists, the local developments in the various tribal areas, specialisation of skills, and the special environmental resources of a region caused many regional art styles to evolve in New Zealand. Such differences of style are most readily seen in woodcarving art. However, as to regional differences, one must remember some craftworkers were itinerant. Through trade and the commissions far from home — notably, carvers and tattooers — the style of one district appeared in another district. Tribal mass migrations, such as that of the Ngati Toa from Kawhia to the Cook Strait region which occurred early in the nineteenth century, conveyed from one place to another entire people with their specific art styles.

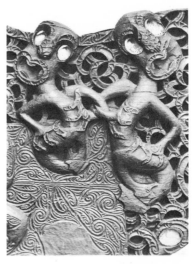

Artistic style in all forms of Maori art is, to a great degree, regional to a tribe and a place. This photographic detail of a large lintel in the Auckland Museum, from Patetonga, Hauraki, represents in essence the sinuous style of Auckland, North Auckland and Taranaki carving, in contrast to the more rigid concept of form typical of other parts of the North Island.

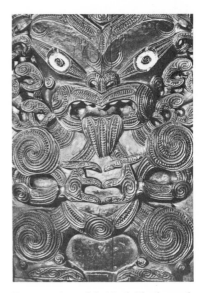

Eastern regions of the North Island, namely Bay of Plenty-East Coast tribal areas and those associated to the south, have woodcarving styles that are of squarish blocked-out forms such as exemplified by this panel from the Te Hau-ki-Turanga meeting house, built at Manutuke (Gisborne district) in 1842. This carving represents the low bas-relief type that occurs in both of the primary district styles of carving.

Related to this subject of definitions is that of classification. Maori artwork can be divided into four categories:

Two-dimensional artworks are those that are flat, or more or less flat, in form. A house rafter may be rounded but in the practical terms of pattern analysis it is flat. Examples of two-dimensional art objects are mats, garments, lattice panels and certain woodcarving panels.

Bas-relief artworks are those carvings that are slightly raised above their base surface. The frontal boards of houses, lintels, house panels, the top-strakes of war canoes, and certain storehouse facade boards are carved in bas-relief of varying depths.

Three-dimensional artworks have depth in all directions and can be viewed from all sides. Central ancestral house post figures (poutokomanawa), musical instruments, and treasure boxes are all measurable in three dimensions.

Fretwork artworks are those that have open holes passing through them. They are sometimes referred to as 'aerial' carvings. Such objects are in a sense two-dimensional, as they are viewed from one side or the other. Carved work of this kind is not common in Maori art. War canoe prows and stern posts provide the best examples of fretted forms.

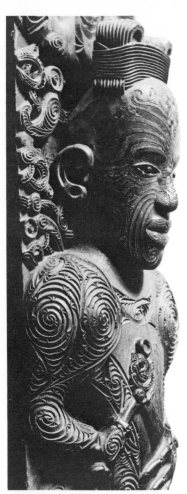

Bas relief carvings were made in high or low relief. This remarkable image, believed to be a personal portrait of Raharuhi Rukupo, the principal designer and carver of the Te Hau-ki-Turanga house, is of very high relief and just one step short of being a freestanding rendering in three-dimensional form. That great treasure, the Te Hau-ki-Turanga carved house, is preserved in the National Museum of New Zealand and may be entered and viewed by all visitors.

In Maori sculptural art three-dimensional objects are either fixed (as in most support post images) or portable. This small freestanding image, height 45 cm, is from the W.O. Oldman Collection, National Museum of New Zealand. It represents a series of early portable figures, which were probably ancestral images placed before posts in houses. These three views illustrate the distinctive rounded nature of such images, yet the front remains the most important viewing aspect.

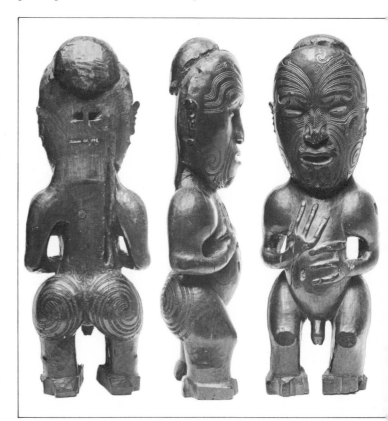

The Maori had terms for each distinctive type of art production and for the makers of things. The word 'tohunga' was generally used to mean a skilled (and priestly) practitioner, e.g., the 'tohunga whakairo' was a carving specialist, the 'tohunga ta moko' a tattooist.

Aspects of View

Maori art is, in general, a 'frontal art'. This means that most of its products were designed to be seen by the viewer from a position in front of the object concerned rather than in oblique view. An example of this basic characteristic is the meeting house with its facade and interior carvings. Front and side walls of storehouses, rafter patterns, tiki wall slabs, and lattice panels were designed to be seen by standing or sitting directly before them. The three-dimensional, freestanding tiki images of Maori woodcarving can be viewed from any angle yet they too are artistically frontal in design. One tends to be drawn to look at them face on. Even smaller portable objects, such as treasure boxes, present to the eye, top, bottom, and side planes — each to be viewed separately. Hei-tiki and many other ornaments, as well as mat and cloak patterns, are decidedly frontal in their designs. Even Maori short clubs are best looked at from one side or the other, and they were represented this way when carved on ancestral images.

The eye level of the viewer of a fixed carved object was evidently taken into account by Maori designers, for example, finial figures and gable masks are designed to be seen from a position below the carvings. The old meeting house short ancestral panels are seen to best advantage from a level at which the eyes are near the mid-point of the carvings. Such panels were designed to be seen by people who were sitting on mats. The panels of the Te Hau-ki-Turanga meeting house in the National Museum of New Zealand (Wellington) appear to be at their artistic best when viewed from a low eye level. In contrast, in modern meeting houses with their high walls carvings are designed for people who either sit on chairs or benches or stand about these hall-like houses.

Maori war canoes were also 'frontal', as their top-strakes, stern posts and prow pieces were best viewed from one side or the other. A complete canoe had its most striking artistic effect when it was seen in profile.

Geometric Basis of Maori Art

Maori art is geometric as well as frontal. Its subject matter is usually ancestors and spirits of the supernatural world, depicted according to certain 'rules' of orderly design. However

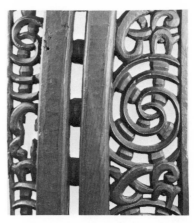

Forms of woodcarving that are pierced through are distinctive fretwork forms that have an 'aerial' lightness of artistic effect on a viewer. A number of different carved objects are of these aerial fretted forms. The most impressive application of this technique is seen in the prows and sternposts of war canoes. Shown here is the detail of a sternpost in the K.A. Webster Collection and a view of a whole sternpost in the National Museum of New Zealand. The chocks that support the spirals and symbols incorporated in such carvings are not intrinsically a part of the design, yet they are put to good artistic effect.

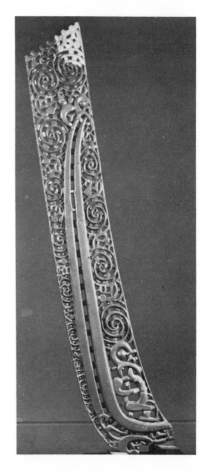

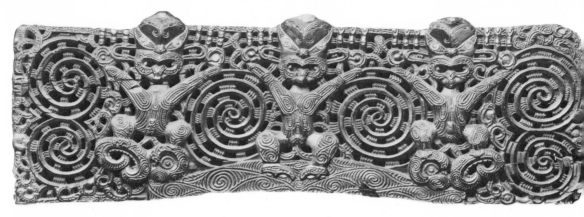

House door lintels, such as this splendid nineteenth-century example in the East Coast-Bay of Plenty style (width 109 cm), are of both bas-relief and fretwork, yet they are seen only from the front. The design of this lintel exemplifies the essential orderliness and basic geometrical planning of Maori art forms.

cluttered and unruly a carving may appear to the untrained eye, balance, repetition, theme, and correct placement of motif is present in all good work. Each artist-craftsman had his individual preferences, yet he was bound by a tradition not only limited in subject matter but in the general principles of composition as well. Straight or curved lines — the rectilinear or curvilinear elements — were manipulated according to approved style by the craft worker.

Symmetrical compositions usually prevail over asymmetrical arrangements. The typical ancestral panel is a flattish symmetrical arrangement in bas-relief with the image spread out over the panel and the main features in balance. The stance, with firmly planted feet, is usually a static one. This is often enlivened by the movement of an arm, twist of the tongue or bend of the head — that is, by the introduction of an asymmetric positioning.

Another basic feature of Maori art composition, particularly seen in woodcarving, is repetition with the alternation of certain symbols and motifs. A Maori storehouse baseboard typically has alternating tiki and manaia with the composition moving outward from a central tiki to terminate in outward-facing manaia. (These two symbols are described on pages 32-39) This plan of composition is also commonly found on door lintels and on some treasure boxes.

Taniko-patterned borders, plaited mats and baskets made from dyed and bleached flax, and lattice panels are, by the very nature of their construction, strongly geometric with designs that must be rectilinear. Rectilinear designs tend to suggest immobility, while curvilinear composition, spirals being dominant, create an impression of movement. Curvilinear carving styles predominated in certain regions, while rectilinear design was strong in other places.

Woodcarving and rafter painting are crafts that offered the easy option of using either curved or straight lines. The general preference in these two crafts was for curves and spirals yet rectilinear elements are present in both.

TWO

Maori Art Symbols and Related Religious Ideas

The pre-European Maori people lived in a world where the practice of ritual and the use of magical objects was believed to be vital to tribal survival. Such rituals often required places where the spirits of gods or ancestors might take up residence for a short or prolonged period. Suitable things were made to receive spiritual entities and, as with most traditional arts the world over, these 'magical' objects were usually elaborated and much-decorated forms of the utilitarian things used in daily occupations.

The Role of Maori Religion

Although devoted to religion, the Maori was also pragmatic. He watched nature with close attention, then exploited the natural resources available in the environment to the extent stone age technology would permit. Common sense prevailed. Everyday life was a practical no-nonsense business in both peace and war, yet a prevailing belief in the power of gods and spirits dominated everyone. Some supernatural powers were considered favourable to mankind, while others were opposed to human existence — evil being personified in the renegade son of Rangi and Papa, Whiro.

Chiefly priests protected the spiritual and practical interests of tribe and sub-tribe. Every man of rank was a priest in his own right, a claim which could be attested to by the recitation of genealogies, some of which reached back to the primeval gods.

In Maori belief all things had a kind of soul — the wairua. Most things — men, manufactured objects, land, and indeed all nature — had a spiritual 'essence' called mana. This vital inner force, which has been likened to electricity, could be drained away by improper contacts. The protection of mana was in certain rules and prohibitive 'laws' called tapu. (The English word 'taboo' derives from the Tongan pronunciation of this word). Mana revealed itself in the efficient performance of anything, whether it was a warrior, a fish hook or a tract of forest. Ceremonial objects were, by their nature, much imbued with mana and were protected by rigid tapu.

The basic Maori idea relating to the creation of the world was that out of the cosmic night (Po) emerged the primal sexual elements in the persons of Papa, the Earth Mother, and Rangi, the Sky Father. Between their embracing bodies male god offspring were born. These sons soon became tired of the confined lightless space of their small world so they rebelled. Tane, who became god of forests and of creative forces, brutally pushed the parents apart to their great lamentations, and Rangi's flowing blood stained the earth red. The Primal Parents are depicted here by W. Dittmer, from his book *Te Tohunga* (1907).

To the traditional Maori mind, spirits of underworlds, earth and the heavens were about all the time in various forms. W. Dittmer here depicts a particular night fairy called the Patupaiarehe, who were generally kind and helpful to mankind if not interfered with or exposed to daylight. One Maori hero stole from them the art of net making by mingling as one of them in the dim starlight.

30

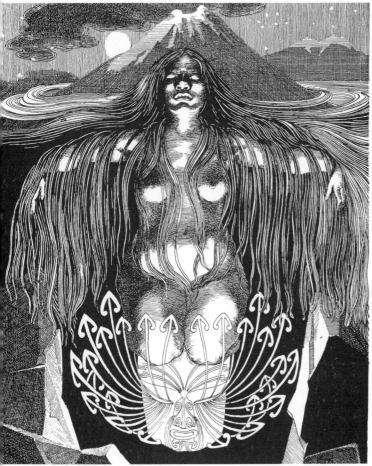

The hero Maui, known throughout Polynesia, was a mischief-maker one cannot but like. He snared the sun to give mankind a longer day, and he even tried to get immortality for all mortals by crawling into the body of the dreaded Goddess of Death. Unfortunately she awoke and crushed Maui in her vagina, on his way to reach the prize that lay in her heart. Dittmer here portrays Maui fishing up the North Island of New Zealand from the ocean floor — one of his many great acts — and Hine nui te Po, the Goddess of Death. Such concepts of life and death inspired the symbolism of Maori art.

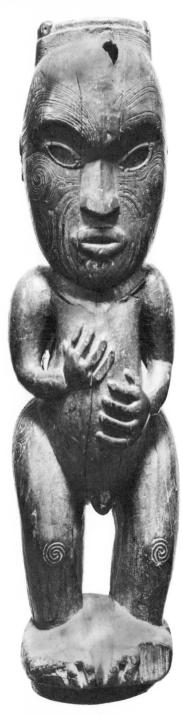

A small unpainted ridgepole-support image (poutokomanawa), standing 91 cm, in the collection of the Hawke's Bay Museum, Napier. The size of such images is an indication of the size of the house they were used in. From the seventeenth to the twentieth century they grew in height as houses grew larger.

Symbols in Carving Art

Closely related to Maori religious ideas are the art motifs. The motifs or symbols in Maori art form distinctive features in most compositions. They may be large or small in size, fully sculptured, in bas-relief, or occur as flat patterns. They appear alone or associated with other motifs.

The principal symbols are few. They are:

Tiki: Images of human-like form, some of which combine or have superimposed on them the features of birds or lizard-like creatures (tiki may represent ancestors, gods, or other spirits).

Manaia: Mysterious creatures that have bird-like heads or bodies that have arms and legs (reptilian features also occur with this symbol). Manaia also appear in fragmented forms, sometimes being represented by the beaks alone.

Moko: Lizards which are generally rendered in a more-or-less recognisable 'naturalistic' form.

Marakihau: Mermen or sea monsters of several varieties.

Pakake: Whale forms which seem to represent monsters (taniwha) rather than ordinary whales.

Tiki-manaia combinations are the most characteristic feature of Classic Maori woodcarving.

The thing to remember about the symbols of Maori art is that very little is known of their deeper meanings or origins. Ancestral images, such as those seen in ceremonial meeting houses, are simply that; their identity is sometimes known, but the symbolic meaning of the details is little understood. Sometimes, the names of the carvers are recorded but with eighteenth-century carvings such information is virtually non-existent.

The minor motifs of Maori art, such as fishes, dogs, and snake-like creatures, are incidentally mentioned in picture captions, but their appearance in pre-European carving is extremely rare.

Tiki

In Maori mythology Tiki personifies primeval man. He was the first man created — a kind of Maori Adam — the offspring of Tane, chief of the sons of Rangi and Papa (the Sky Father and the Earth Mother). Generally speaking, all carvings that resemble the human form, regardless of their sex, may be called tiki. Many different kinds of tiki were made for different purposes. Some served as dwelling places for ancestral spirits while others served as the vehicles of gods and other supernatural entities.

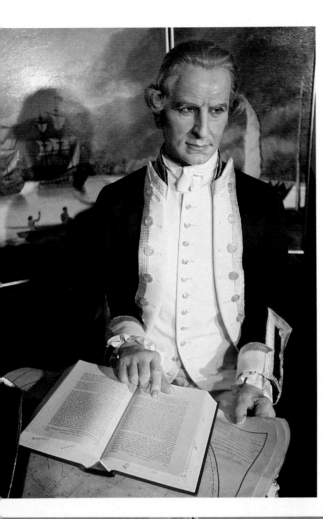

Left: An effigy of Captain James Cook in a diorama displayed on the Swedish vessel *Kungsholm*, which, two centuries after Cook's landing on New Zealand in 1769, cruised to places associated with this admirable man. Cook was a remarkable observer of Maori life and collector of Maori 'artificial curiosities', as artefacts were then called.

Below: An imaginative reconstruction of a Polynesian voyaging canoe with a companion vessel (the sails of which are just visible) making a moonlight landfall on Ao Tea Roa — a Maori name for New Zealand. When the Maori ancestors arrived is unknown, yet it is certain they arrived in efficient, seaworthy vessels, guided by skilled navigators. This study, by Herb Kawainui Kane of Hawaii, is in the collection of the author.

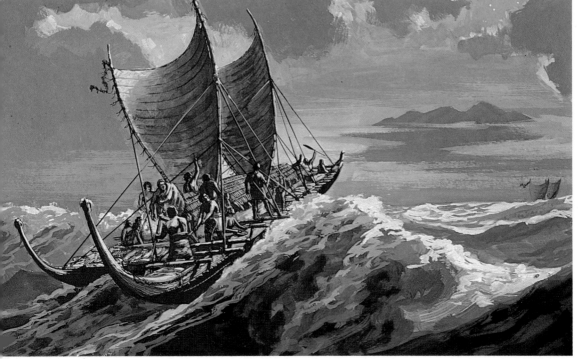

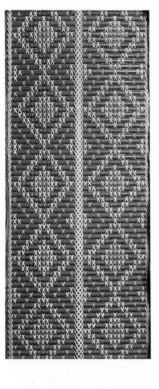
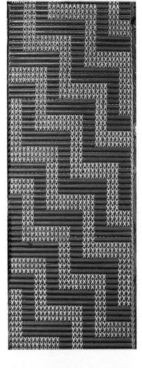

These six examples of stitched tukutuku panels, designed to be set between the posts of Te Hau ki Turanga in the National Museum of New Zealand, were made under the direction of Sir Apirana Ngata in the 1930s restoration of that house.

The designs are (clockwise from top left): patiki (sand flounder); poutama (steps or 'Stairway to Heaven'); kaokoa (human rib); mangoroa (the Milky Way); roimata toroa (albatross tears); wharua (double mouth). (National Museum, Wellington).

Most carvings are impersonal and stylised, yet a few are distinctive individual portraits. Some have naturalistic heads and abstracted bodies. In Maori eyes, tattoo patterns identified a man more than the features of his face. Every carving formerly had an identity, that is, it represented a particular ancestor or spirit. Unfortunately, knowledge of the names of all but a small number of these tiki has been lost. Collectors of the eighteenth and nineteenth centuries were rarely concerned with who they represented. Some nineteenth-century house panels have names carved on them — usually across the breast of an ancestral panel — which provide positive identification.

The depiction of the ancestors as carved images was to commemorate great people in tribal history. The individual ancestral figure carvings that appear in rows as the panels of meeting houses, were regarded as places where the spirits could dwell to comfort and protect the living.

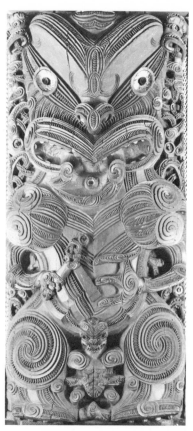

The ancestral wall panels (poupou) grew larger as houses developed higher and higher walls. The few old poupou in existence are of small dimensions. This panel is one of those in the Te Hau-ki-Turanga house in the National Museum of New Zealand. Like its companions, it is about shoulder height.

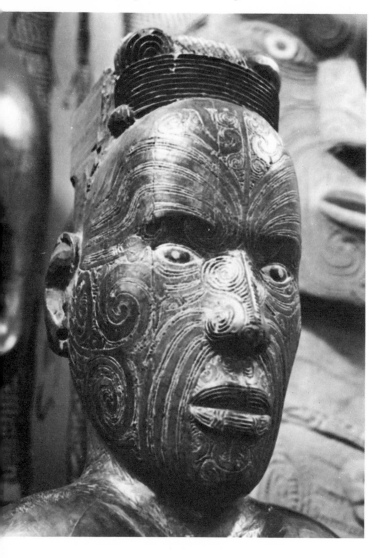

Head of a ridge-support figure (poutokomanawa) from Manutuke in the Gisborne district. It was carved about 1860 by Timote Tuhi and was intended for a house to be built at Te Hapuku in Hawke's Bay. The tattoo pattern is said to be that of the fighting chief Te Hapuku. Generally, the overall impression is that a particular individual is represented. Hawke's Bay Museum, Napier.

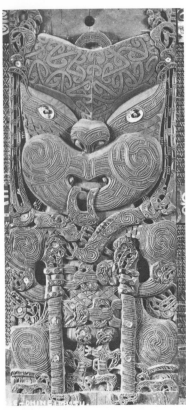

The identification of particular ancestors depicted in carved house panels can sometimes be determined by symbolism related to them. This panel from the Tama-te-Kapua house, opened in 1872 at Ohinemutu, Rotorua, represents the ancestor for whom the house is named walking on stilts. In the ancient East Polynesian home islands Tama-te-Kapua used stilts to steal breadfruit from a neighbouring chief and was forced to leave his home island because of wars resulting from this act.

Almost all Maori sculptural carvings of tiki represen ancestors, but a few represent gods. Stone carvings also serve as the resting places of spirits, such as the images place in gardens.

Maori tiki heads are usually symmetrically formed. An out thrust tongue may swing to the right or the left, while the uppe and lower limbs may be set in varied positions. However, th mask-like face of a tiki, even when bent to one side or the other retains the balance of its two halves. It is as if the face wa formed by two identical profiles.

There is debate among scholars over this device of formin a full face by joining two profiles. Some have claimed th manaia is merely an ancestral figure rendered in profile, ye this theory is loosing ground. The manaia is, itself, a distinc profile form, while the tiki is a frontal and full-faced form which has its own profile form in the ngututa. This distinctiv profile form is unlike the manaia, although some scholars sa ngututa is a manaia form.

There are tiki that are portraits of individuals, the mai means of identification being in their facial tattoo designs Examples of fine portraiture in Maori wood sculpture are t be seen in museum collections; for example, that of the maste carver Raharuhi Rukupo which stands inside the Te Hau-ki Turanga meeting house — a Manutuke house now in th National Museum, Wellington; and the figure of the Hawke Bay chief, Te Waaka Perohuka in the Hawke's Bay Museum Napier.

Some ancestral panels may be identified by a symbolic objec which the figure has on it or holds in a hand. The Te Araw ancestor Tama te Kapua is shown with walking stilts, whil Tutanekai, who lured the maiden Hinemoa to swim to hir across Lake Rotorua to Mokoia Island by the love calls of hi flute, is shown with his famous instrument.

The place of origin of a particular carving is indicated b its regional art style. Also, it may have a history connectin it to a place. However, carvers sometimes travelled to take u commissions far from home. Consequently, a house panel o other carving may have been carved in a style not typical o the district in which it was made.

Sexual symbolism in tiki is at times conspicuous. The sexua organs were regarded as highly sacred, like the head of th body, and of such mana as to be centres of magical powe Maori religious belief was closely associated with ideas o sexuality. Before the gods were created, the Earth Moth (Papa) was joined in sexual embrace with the Sky Fath (Rangi) over eons of time. When the god children were bor — all of them male — they lived in the dark and cramped spac between the bodies of their parents. Eventually Rangi and Pap

were forced apart by Tane so light came into the world. Thus the sky is Rangi and the earth is Papa.

Tiki figures may be of the male or female sex. In Western sculpture or painting, the sex of figures is usually indicated by the form of the body, the sexual organs themselves conventionally being concealed. In strong contrast, Polynesian tribal art indicates gender by depicting the sexual parts — the penis of the male or the vulva of the female — often in exaggerated size. Birth figures are set between legs or on the torsos of some images, or a mask is carved in the pubic area to suggest the head of a newborn child.

Sexual symbolism in carving art is obvious enough, yet its meanings are obscure. It indicated the need for fertility, for survival of the tribe, and the Maori belief that sexual organs possessed magical protective power.

The penis, especially in its erect state, was a positive indication of the virility of the warrior ancestor. The sexual parts of a woman were regarded as having powerful magic of negative kind, which was utilised in several ways. For example, if a woman stepped over a sick person (illness being regarded as caused by an indwelling evil spirit), that person might be healed by the tapu-destroying power of the woman's sexual parts. Tapu was lifted from a new dwelling or meeting house by having a woman step over its threshold.

This notion that the sexual organs of a woman could destroy invisible spirit forces, especially evil ones, is the probable reason for the placement of one or more female tiki on door lintels. By passing under these female images, those entering a house had any spirits or undesirable influences that clung to them neutralised. Thus, the house and those inside were protected from evil forces.

Figures in positions of sexual intercourse appear carved on treasure boxes, storehouse facade panels, the underside of some house ridgepoles and in other places. They too seem to relate to the ideas of the potency of sexuality in providing both protection and tribal fertility. Some sexually joined figures are believed to represent the Earth Mother in union with the Sky Father.

Whatever the reasons for sexual symbolism in carving art, it seems certain that they relate to magic rather than entertainment. In traditional Maori culture there was no exploitation of sex as exists in the modern world. Furthermore, Western ideas connecting sex with sin never occurred to the traditional Maori. Such ideas came with missionary teaching.

The out-thrust tongue which features on so many ancestral carvings had a protective objective quite apart from its being a gesture of defiance. (This act amuses modern audiences who watch war dances presented by living dancers as entertainment

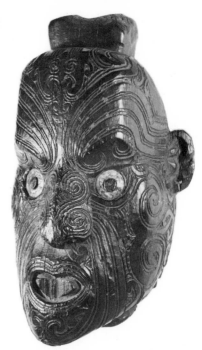

Eighteenth-century portrait mask of uncertain use. It has a powerful expression, with distinctive tattoo patterns and shell eye inlay. Formerly it had an out-thrust tongue, which has been broken off. This fine head is in the collection of the Museum of Mankind, British Museum, London.

and seem unaware that this was not a humorous act to the Maori.) Throughout the Pacific and Asia the protruding tongue of carvings was symbolic of protective magic. The carvings of ancient China and the South-east Asian region, those lands associated with the distant ancestors of the Maori, are often depicted with an out-thrust tongue. In those places the beliefs regarding the protective power of this organ prevailed.

A spiral occasionally appeared carved on the tongue, adding to the impression of its mobility, and the appearance of spirals at the joints of tiki figures gave their limbs an impression of flexibility. The spirals placed on faces, buttocks, elbows, knees, ankles, and other parts of carvings certainly enlivened tiki. They were an effective artistic device.

Many of the contorted stances of the tiki suggest postures of war dances. The curving of the bodies and twisting of arms and legs also enabled the artist to fill in panel areas that would otherwise have been left vacant.

The importance of the head was also helpful in filling panel areas, as it could then be carved large in relation to the body.

To appreciate Maori carving one must not apply to it the canons of Western painting or Western sculpture. Maori art is a tribal art, far removed from the concepts, purposes, and artistic traditions of European civilizations. It has similarities with the arts of the Celts and Vikings. Suggestions of past connections with such far-off cultures may seem far-fetched, yet many scholars believe in such relationships via Sythian and other Asian cultures.

Avianised Tiki

The word 'avian' pertains to birds. Most Maori tiki, however 'human' in form, possess certain bird-like features. Some carvings are distinctly avian to the point of being 'birdmen'. Birdmen occur in many Pacific island arts as well as in the arts of South-east Asia and China. The association of the souls of the dead with birds, as their spirit vehicles, is universal, and such bird or birdman symbols are seen in many traditional arts.

The Maori certainly associated the spirits of the deceased with birds, most particularly with the owl (ruru), which often served as a totem guardian of the living. Winged birdmen are seen in the rock paintings of New Zealand, and birdmen and birdwomen are described in many myths. Birds served the Maori as guardians, givers of omens, and vehicles of spirits. Their cries were listened to and their movements watched with care. It is not surprising to observe bird features in ancestral tiki.

The avian characteristics are evident in the round, lidless staring eyes, the slanting beaked lips, and clawed hands which

n some cases have distinctive talon 'fingers' that are formed by three claws and a spur-formed 'thumb'. Avian features are particularly noticeable on the bone chests of the Auckland district. Some northern carvings include figures that have the webbed feet of seabirds.

The owl motif is well-defined and is personified by Koururu (Rongo, who acquired the art of carving from the supernatural world of the gods, made a sacred offering of Koururu by burying its body under the wall of a house). Such carvings exhibit large, round, staring eyes, and at times the ear tufts of the owl.

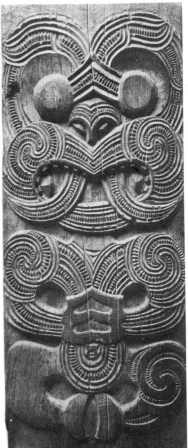

A noted carving symbol shown here is the Koururu, a personified form of the owl (ruru). The distinctive avian features of this carving are seen in the staring eyes, beaked mouth, and feather-like ear tufts above the brows. The photograph is a detailed section of a ridge beam from Rotorua, in the collection of the National Museum of New Zealand.

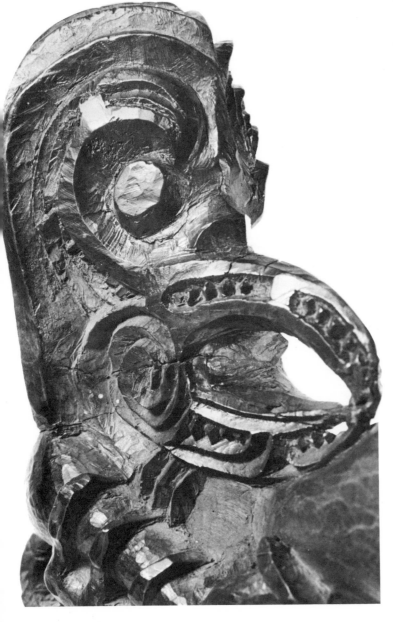

Birdman features so often found in carving are nicely represented by this mask on the heel of a ceremonial adze in the K.A. Webster Collection, National Museum of New Zealand.

Manaia

Next to tiki, the manaia is the predominant motif of Classic Maori carving art. It is a symbol of woodcarving that appears mostly closely related to tiki. It is at times found alone, e.g., as jade (pounamu) or bone ornaments.

What manaia meant to the traditional Maori remains a mystery. We can speculate on its function. It was no doubt a magical symbol. In its typical form it had a tiki body with a bird-like head. It was often fragmented, with the head or even the beak alone appearing in carving compositions. Sometimes it was incorporated as part of the tiki body, such as forming the hands, or overlaying the torso.

Manaia 'behaviour' is unpredictable. When it stands next to a tiki it often 'bites' into the tiki head, or grasps the body with its upper or lower limbs. Manaia beaks were often used to fill in areas of panel or lintel. The interlocking of manaia beaks with adjoining manaia formed elementary, interlocking spirals. The hand of manaia was clearly of the claw type. As a rule, manaia did not have sexual organs, yet a few were sexually defined.

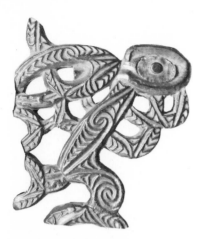

Above: Cutout of a manaia from a photograph of a lintel in the Museum of Mankind, British Museum.
Below: Cutout of a manaia made from a photograph of a treasure box in the K.A. Webster Collection, National Museum of New Zealand.

The manaia symbol takes on many forms, notably in East Coast-Bay of Plenty carving. Line drawing (a) is from a direct rubbed impression of a manaia in the Te Hau-ki-Turanga house. Line drawing (b) analyses the parts of the same manaia.

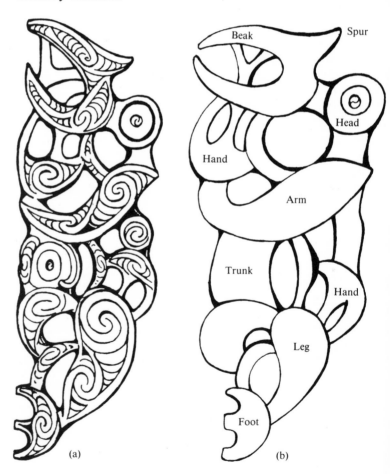

(a) (b)

When set with tiki on baseboards or sides of foodstores, on lintels, or along war canoe strakes, manaia and tiki usually alternate in the design. Often there is a central tiki with the composition terminating in outward-turned manaia. These outer manaia, especially when on door lintels, interlock lips with a kind of beaked snake, which the 'attacking' manaia grasps with its 'hands' and 'feet'.

The only consistent thing about manaia is its inconsistency. At times it seems to resemble a lizard. Manaia-headed lizards do occur in some instances. The lizard-form bone chest in the Auckland Museum is an excellent example.

A feature of the upper mandible — the upper part of the 'beak' of manaia — is a kind of spur which resembles the egg-breaking protrusion often possessed by fledgling birds.

Manaia are often paired to form a face, as seen on the flanges of some canoe bailers. The nostrils are then set above these beaks, while the eye and brow parts run up either side of the bailer's rim.

The Maori carver's genius for combining images to provide what we might call 'double meanings' is an important facet of Maori design. Sexual symbolism made its appearance in the design of canoe bailers, as the protruding handle could both form the neck of a manaia and also represent a phallus.

Manaia also appeared as small jade ornaments, some of which have heads at both ends. Others were of a coiled eel-like form.

Manaia were most abundant, and varied, in the carving arts of the East Coast — Bay of Plenty regions of the North Island. They were also found in numbers in carvings found in the Taranaki and Auckland districts.

Manaia exploitation was extreme in the metal tool work of the Bay of Plenty nineteenth-century carvers. However, many old treasure boxes also exhibited complicated arrangements of manaia so the practice is not post-European.

Manaia seem to be symbolic of the mana (prestige and power) of the ancestral tiki they accompany, but no one has yet substantiated this idea.

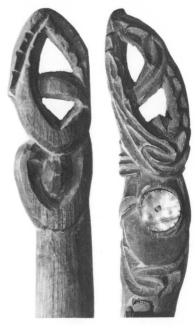

Manaia heads were often used as terminations on paddles, handles of canoe bailers and of short clubs. These two examples are:
Left: Manaia head at the top of the handle of a paddle in the Museum of Mankind, British Museum, London.
Right: Manaia head at the end of the handle of a fisherman's scoopnet in the National Museum of New Zealand.

Bone chest in the general form of a lizard with manaia head. This unusual box, 122 cm long, was found in the Kohekohe burial cave at Waimamaku, Northland, and is in the collection of the Auckland Museum. It is said to have been placed at the entrance of the cave as a warning mark (rahui) to indicate that the place was forbidden (tapu) to all unauthorised persons.

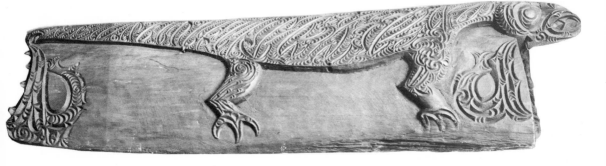

The pervading fear of certain lizards in traditional Maori thought is believed by some scholars to be rooted in an ancient racial memory of the crocodile in the South-east Asian and northern Melanesian regions. It was regarded there as a potent symbolic image. This rubbed impression of a crocodilian looking lizard is from the haft of a ceremonial adze in the James Hooper collection of Oceanic artifacts.

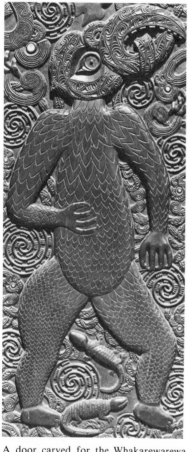

A door carved for the Whakarewarewa (Rotorua) house Nukunuku-te-Apiapi, about 1905. The manaia-headed birdlady depicted with lizards between her legs is Kura-ngaituku, who made a pet of the culture-hero Hatupatu. He escaped and, when chased by this infuriated birdlady, managed to get away. This carving is at the School of Maori Arts and Crafts, Whakarewarewa.

Lizard

The lizard motif in Classic Maori art, whether carved in wood or bone, is rare. It is seen more often in nineteenth-century woodcarving. Reptiles in general, the 'ngarara', were not favoured by the Maori as they were believed to serve often as the vehicles of harmful spirits, particularly of Whiro, the god who symbolised death and destruction. Certain species were particularly feared as that god's emissaries. Generally lizards were vehicles of the lower gods and were avoided.

If the gods wished to kill a man, it was believed, they would send a lizard to enter his body and eat away his vital organs. Yet some lizards served as guardians and powerful deterrents to those who might wish to steal and degrade the dead, and they were sometimes carved as markers of sacred places. The lizard-form of the bone chest with a manaia head mentioned earlier probably served as a protective guardian of the bones placed in it.

Marakihau

Monsters of various kinds were called 'taniwha'. They were said to lurk in caves on land or along sea coasts, in rivers, and, as a class, were feared as they readily attacked humans. The marakihau depicted in carving is a taniwha of the sea. Some were believed to be the spirits of ancestors that had taken up residence in the ocean.

They were usually depicted as mermen with sinuous bodies that terminated in curled tails. Their heads sometimes had horns, while their spines were lined with jagged fins. Their eyes were large and round. Their mouths had tube-like tongues that could suck in a fish, or whole canoes and their crews.

Pre-European representations of marakihau appear in a few carvings. They were seen as small nephrite ornaments and were incorporated into the designs of northern treasure boxes.

Other creatures of the sea, such as fishes, were found in early Maori rock-wall painting and in some ornamental forms. Certain greenstone ornaments, such as the hei-matau (a stylised fish hook), combined the form of hook and sea mammal. Yet, overall, sea creatures were few in Maori art.

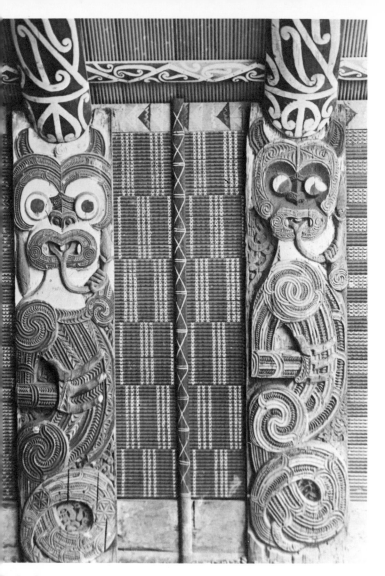

A rubbed impression from a Northland feather box showing a distinctive marakihau type of image. Features of the northern style are the curved body, distorted in a rhythmical way, and a highly domed head.

Two panels depicting marakihau ancestors in the nineteenth-century Te Tokanga-nui-a-Noho meeting house, which stands at Te Kuiti in the King Country. Unfortunately the old polychrome paintwork seen in this photograph was overpainted with oil bound red paint in a twentieth-century restoration. The panels have some of the sinuousness of Taranaki and North Auckland regions, yet they are basically in the blocked and squared form of the eastern and southern style of the North Island.

akake

The pakake by dictionary definition is simply a whale. In carving art it appeared on the slanting facade boards of torehouses in a stylised form, with large spirals representing ts jaws. Stranded whales presented the Maori with a wealth of flesh and bone, so the use of this creature's form on torehouses probably conveyed the idea of abundance.

As presented in carving art, the 'whale' probably represented taniwha — not an actual whale. Attendant manaia figures vere placed over the basic 'whale' motif so that its form is not eadily seen. The magnificent foodstore boards from Te Kaha, now in the Auckland Museum, have manaia figures pulling great animal ashore. The 'rope' they use is composed of a tring of tiki figures. The lower parts of these two great facade poards terminate with large manaia, which appear to be leading he hauling process.

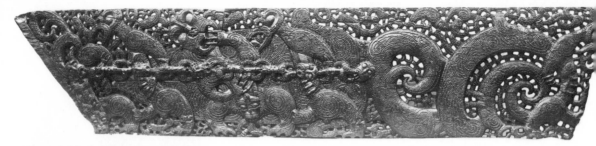

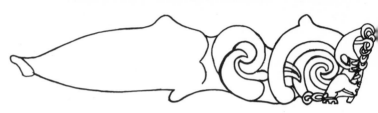

The 'whale' (pakake) (*above*) is here magnificently carved on a storehouse barge board, which was found in a cave near Te Kaha, Bay of Plenty. Manaia and tiki overlay the main whale, which is outlined in line drawing at right. A row of sexually joined smaller figures form the 'rope' that the larger manaia is pulling as if to draw this creature ashore. Auckland Museum.

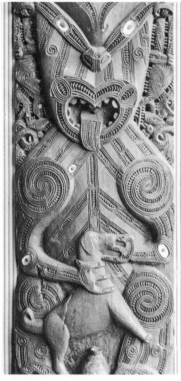

The dog was the only red-blooded animal companion of the Maori. It served him in bush hunting, as a pet, and as a valued source of flesh food. Dog skins and bone were also useful in a number of ways. The dog appears in both Archaic and Classic art. This panel of the 1880s house Te Mana-o-Turanga, which stands at Manutuke (Gisborne), depicts the ancestor Tutekohi and his pet dog. This dog was stolen and eaten by neighbours, an event which caused a tribal war which resulted in much bloodshed.

Dog

The dog as an art motif is ancient in New Zealand. It appeared in an Archaic Maori amulet found in the Monk's Cave at Sumner near Christchurch. It occurred in abundance in the drawings on the limestone rock shelters of Canterbury and more southern areas of the east coast of the South Island. Its general absence from pre-European Classic Maori carving is surprising as the dog was a most important animal to the Maori, both as food and as a domesticated hunting companion. A nineteenth-century rendering of a dog appears on a panel depicting the ancestor Tutekohe in the Te Mana-o-Turanga house at Manutuke, Gisborne district, and also appears in several Arawa houses. Fine dog-form bowls were carved in the mid to late nineteenth century.

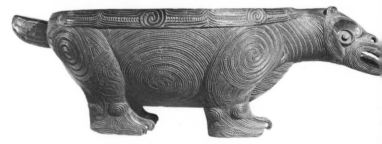

This manaia-headed bowl with a dog-like body is of late nineteenth-century origin. Its length is 101 cm. Several such bowls exist, all from the Bay of Plenty. This example is in the Cambridge University Museum of Archaeology and Ethnology, Cambridge (England).

THREE

Pattern, Design Elements and Craftsmanship

Sculptured wooden objects are three-dimensional, high or low bas-relief, or open fretwork. Namely in order of examples — free-standing tiki, house panels, and prow and stern carvings of a war canoe. Ivory, bone, and stone were at times similarly carved within the limitations of the material.

Carved objects had surface patterns added to them by the cutting of grooves, notches, and incised lines, or by painting.

Flat patterns formed by stitching, as in tukutuku panels, mat and basketry soft-fibre plaiting and garment 'weaving', yielded a great range of two-dimensional patterns. Such patterns emerged from craft technique and the craft worker's planned manipulation of the particular material.

Koru

The best known and most widely used Maori art motifs are the koru and the spiral. The koru is basically a stalk with a bulb at one end. No one knows how it was first invented or who elaborated this versatile element of pattern. Certainly, an unlimited range of patterns can be formed from it.

Koru-like motifs are present in the arts of ancient Asia, notably in the areas of southern China and South-east Asia. They abound in the tribal arts of Melanesia. The Maori koru probably had its origins in such regions and was carried to New Zealand by the Maori ancestors.

The word koru is defined in Williams *Dictionary of the Maori Language* as an adjective meaning 'folded, coiled, looped'. As a noun, the word means 'a bulbed motif or scroll painting'.

A popular explanation of the koru is that it represents the unfolding of a tree fern frond, as seen in the uncurling corm with its rolled-up inner leaflets. The koru also resembles a curling wave. When it is set in elaborate patterns, such as rafter designs, it also resembles the tendrils of other vegetation, especially of the gourd plant (hue).

The koru is present in pre-Classic Maori art on artefacts of distinctive archaic style. One notable example is a flat knife found in Southland and now in the Otago Museum, Dunedin.

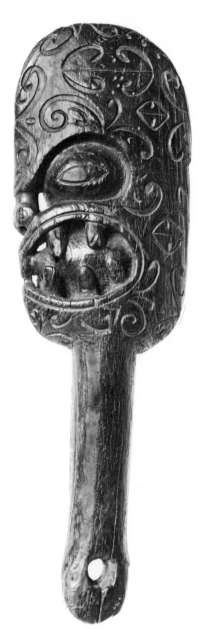

A very old wooden short club (26 cm) of an Archaic Maori style was recovered from a swamp at Ohaeawai, North Auckland. Koru and spiral motifs carved on the surface of this weapon reveal an early use of these basic designs. K.A. Webster Collection, National Museum of New Zealand.

43

This object made of slate has two koru incised on its face.

The koru motif has its most obvious application today in rafter pattern design. Formerly it was used in facial tattoos, gourds, and woodcarving art. In woodcarving it was used notably to represent tattoo on tiki. Preserved dried heads present a remarkable range of 'koru' patterns.

The basic koru unit is a kind of bulbed stalk which can be rendered in simple line, in silhouette, or as a blocked-out form as shown in the examples here.

Simple line koru Silhouetted koru Blocked-out koru

The single element koru were combined with other koru in many ways. Basic elaborations were achieved by the joining of two koru on a stalk to form a kind of arrow, which can be arranged either symmetrically or asymmetrically. Another combination is the double-ended version of the first form. It can be balanced or unbalanced as shown:

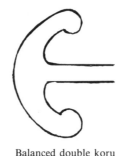

Balanced double koru Joined double koru — balanced

Joined double koru — unbalanced Koru with inner secondary element

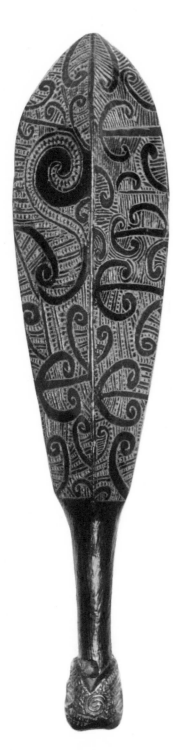

Wooden bludgeon (43 cm) which has on its surface koru and spiral motifs of the Classic Maori kind. K.A. Webster Collection, National Museum of New Zealand.

Koru was the basic rafter pattern design element. However, it was combined with crescents and dots (the bulb end of koru). A variety of designs were developed from koru, the associated lines, crescents, dots, and other art devices.

Elaborate rafter pattern designs based on koru developed during the nineteenth century, as the great carved meeting houses evolved to meet new social and political conditions.

The oldest painted patterns on preserved wood are those found on canoe paddles of a rare type. In the painted work of these, red ochre pigments were used to block out patterns. The raw wood areas left unpainted formed the design.

The early craftsmen who painted such koru-type patterns were very free in their design. They exhibit none of the ordered precision of modern koru work. Their painting was highly individual in character. The old patu from the Webster Collection and the koru surface carvings on treasure boxes reveal this freedom of renderings.

Red and black pigments were used in combination with white or bluish clays in traditional Oceanic art. In pre-European times, the Maori used red ochre called kokowai mixed with shark's liver oil as a paint. It was applied to many valued objects.

Painted patterns on wooden tombs and memorials of the early nineteenth century were well recorded by the artist George French Angas. His sketches provide an interesting record of koru patterns as applied at that time.

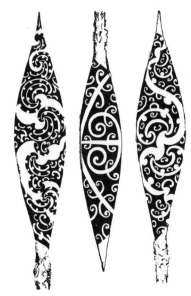

Wooden paddles with red painted kowhaiwhai-type patterns collected on Captain Cook's visits to New Zealand in the 1760s-1770s. Collection of Museum of Mankind, British Museum, London.

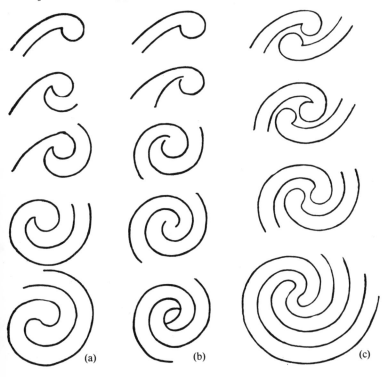

(a) (b) (c)

Line drawings showing a possible development of spiral forms from the basic koru element. After W.J. Phillipps, *Maori Rafter and Taniko Designs* (Wellington, 1960).

45

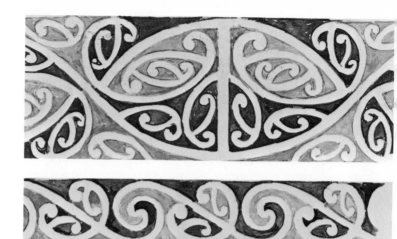

Watercolour drawings of two rafter (kowhaiwhai) designs by Major General H. Robley, who served in the New Zealand wars of the post 1860s. Collection of Hawke's Bay Museum, Napier.

Koru and Spirals

For thousands of years people have drawn spirals. Young children playing in sand often draw simple spirals with finger or stick. It is a natural art motif that became highly developed in Maori art. There was an interrelationship between koru and the spiral, and they probably evolved simultaneously.

An interesting graphic illustration of the relationship of koru and spiral forms was presented by W.J. Phillipps. In this concept a simple line koru, at the extension of its lower lines, curls around to form a looped double spiral (page 45, a). If the upper lines at the bulb end of such koru are detached and extended in the same way, an interlocking double spiral results from the process (b). In a related process, if two simple koru are placed together in an opposing position, with extension of lower curved parts, an interlocking double looped spiral is created (c).

Koru and Tattoo

Koru-based patterns are seen in elaborated form in Maori facial tattoo. They are seen incised on the faces of many tiki images, and on the remarkable mummified heads of Maori warriors. Old Maori portrait sketches and early photographs provide more examples. Nineteenth-century artists, namely Gottfried Lindauer and Charles Goldie, featured tattoo in their portraiture of the Maori.

Nowhere is the koru depicted in greater diversity than in the sketches and paintings of the soldier-artist Major General Horatio G. Robley. He assiduously collected Maori heads after the wars between the Maori and the Pakeha. He had also

Opposite: View of rafters with kowhaiwhai designs in the Te Hau-ki-Turanga carved meeting house, National Museum of New Zealand.

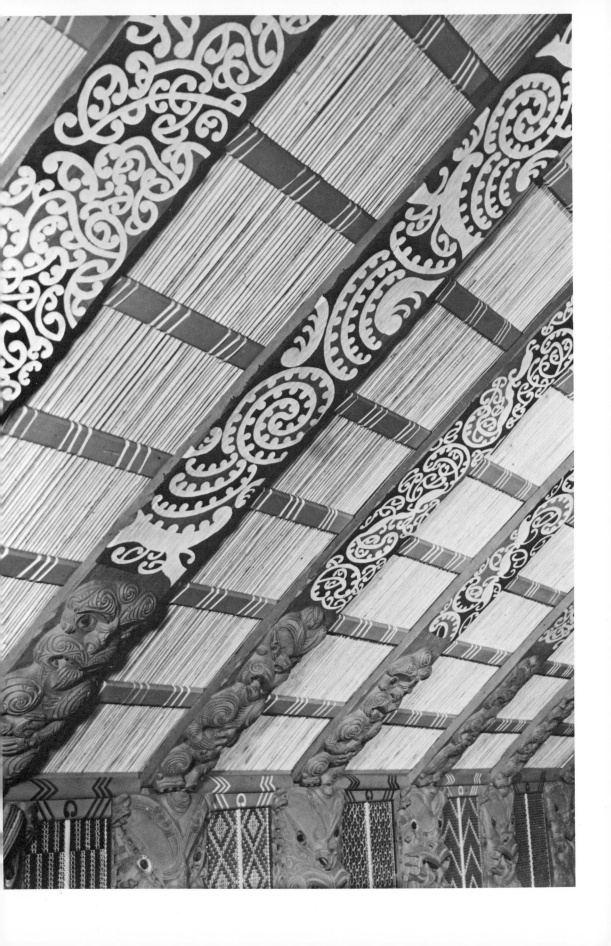

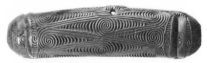

A small flute (17.7 cm) of the koauau type, carved in the North Auckland style. The long rolling spirals are of the pakuru type. Collection of Museum of Mankind, British Museum, London.

Six interlocking spirals with differing types of inter-linear notching, from a series of 46 spirals carved as samples in 1946 at the Dominion Museum (now National Museum of New Zealand) by R.K.P. Porete of Ngai Tahu. This interesting experimental work was conducted under the direction of the Museum ethnologist of the time, W.J. Phillipps.

sketched living tattooed warriors. Many of the complex designs he recorded are to be found in his book, *Moko or Maori Tattooing*, and in the numerous watercolour sketches that are in museums and private collections. The koru was, one might say, his speciality.

The basic design of Maori facial tattoo consisted of a pair of large spirals on the cheeks, small spirals on each side of the nose, and lines sweeping from nose to chin and from the central brow to the temples and forehead. The koru-related areas were seen as 'fill-in' patterns in the unoccupied space of the main design, between the ears and cheeks, on the upper forehead and on the chin. The illustrations demonstrate the unequalled richness of koru in this area of Maori art.

Tattoo on warriors extended to the buttocks and thighs, particularly among the Maori of the northern regions of the North Island.

Tattoo on women was mostly confined to the chin, but occasionally forehead designs occurred. Koru appear in the deep cut patterns of the chin, while the lips were rendered a bluish colour by the less severe 'comb' type tattoo chisel.

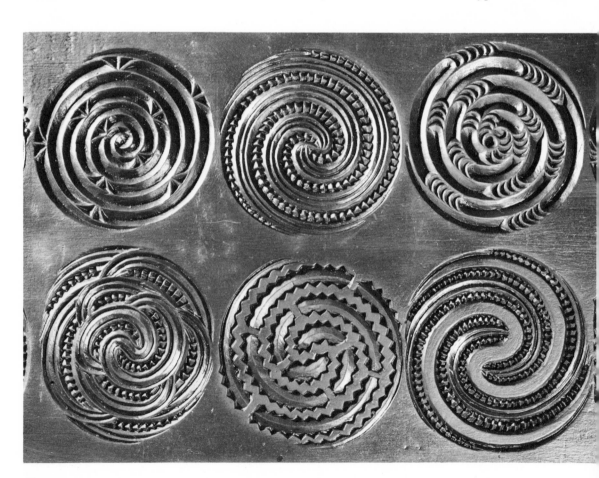

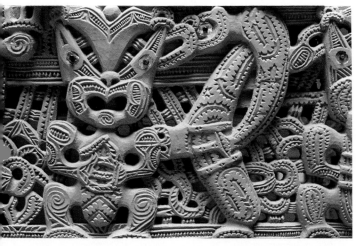

ection of the frontal base board of the Te Oha storehouse, erected at Mourea, een Lake Rotoiti and Rotorua, in the 1820s. This portion of the board illustrates anaia and a tiki in typical relationship. This fine structure is now in the Maori of the Auckland Museum.

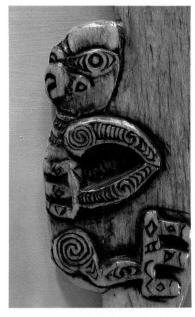

Small tiki carved on the lower end of the blade of a short bone club of the wahaika type. The addition of such small images, usually representing ancestors, added to the mana of objects. This club is in the National Museum of New Zealand, Wellington.

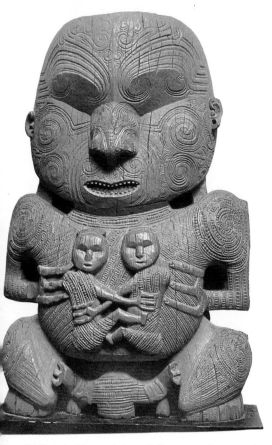

rge tiki figure with coupled small figures on the stomach. wood sculpture stands two metres high and was the upper of a gateway entrance to a fortified village.

Ceremonial meeting houses of the later nineteenth century assumed a great importance in many Maori communities as centres of tribal revival and spiritual renewal. The historic Tama te Kapua house of Ohinemutu, Rotorua, built by the Ngati Whakaue people in 1878, is one such house. The illustration shows the facade of Tama te Kapua, with the author sitting in the picture.

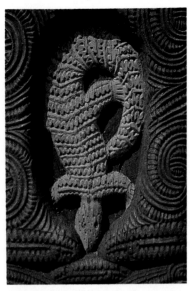

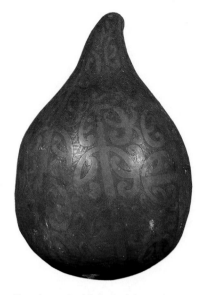

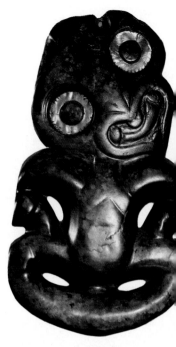

A detail of a frontal post of the Te Hauke house. This green-painted lizard is set between the legs of the ancestral tiki of the carving. With the advent of European paints there arose an attractive poly-chromatic art of adding red, white, blue, green and other colours to carvings. Unfortunately, the fashion this century was to paint over old work with monocoat red.

Gourd vessel with incised koru patterns. The rinds of gourds were cut into a variety of shapes, notably as horizontal bowls, foodpots and waterbottles.

Neck ornaments called hei tiki were w suspended on a deftly made flax fibre c They represented particular ancestors usually had personal names. They w made from varieties of greenstone and w especially treasured as heirlooms associa with forebears.

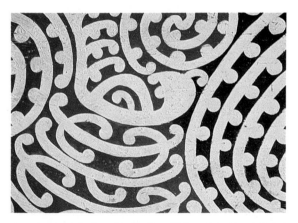

A sectional detail of a painted rafter with koru-based kowhaiwhai design. This excellent example of Maori painting art was from the old Christian church of Ohinemutu, Rotorua.

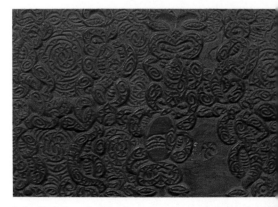

A detail of the underside of a treasure box (wakahuia) of exqui workmanship. The complex design includes tiki and man figures, and small looped interlocking spirals. One sectior unfinished.

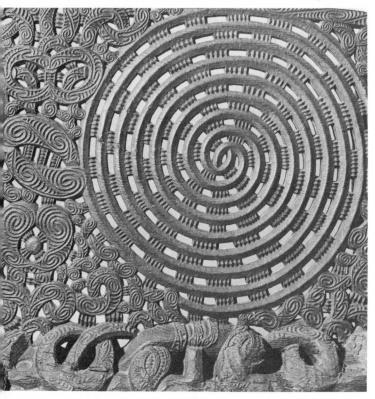

There has been a debate for many years among Maori art experts regarding the difference between stone and metal cut carvings. It is true that when iron or copper tools were made and used by craftsmen trained in the tradition of working with stone tools, the resulting articles could look like stone cut work. On the other hand, the precision and clean-cut work produced by European-manufactured steel tools is unmistakable. This detail of a section of an early nineteenth-century war canoe prow in the Taranaki Museum (New Plymouth) illustrates steel tool work at its best.

Materials and Tools of Craft

The materials of Maori art were either hard substances such as stone, bone, and wood, or soft, pliable substances, such as vegetable fibres and feathers.

Generally, as mentioned before, men worked the hard materials while women worked the soft materials. A knowledge of the basic tools and raw craft materials is necessary for an understanding of the Maori visual arts.

The tropical island homelands of the Maori ancestors had provided materials such as coconut palm and pandanus products, coral, and pearl shell, which were not present in New Zealand. The earliest Maori settlers were obliged to search for, and experiment with, new materials in a strange environment. This they did with remarkable ingenuity.

Polynesian life had always been a struggle for survival. Tools were, by modern standards, primitive. Wood had to be cut with stone, shell or bone blades. Stone was shaped by flaking and grinding. There were no animals of burden, wheeled carts, or machines to help. Raw materials, however abundant, were worked with patient and strenuous manual labour.

Before the arrival of Europeans bearing metal, Maori culture was a purely stone-age culture, but a highly evolved one, at the Neolithic or polished tool level of development. All the materials for tool manufacture and craft work were obtained

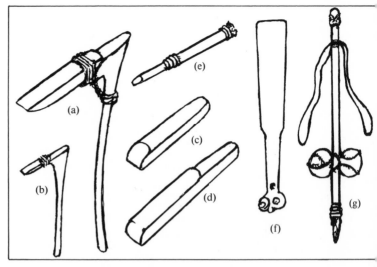

Line drawings of the basic tools of the Maori carver:
(a/b) heavy- and light-weight stone-bladed adzes.
(c) untanged adze blade of Classic Maori type.
(d) tanged adze blade with stepped butt-end to help hold lashings in place.
(e/f) stone-bladed chisel mounted on wooden handle, and a whalebone carver's mallet (wooden mallets also used).
(g) stone-tipped rotary drill.

directly from nature. They included forest woods; bones of whales, birds, dogs and humans; ivory teeth; and stone of many kinds. The volcanic glass, obsidian, was widely traded, as was nephrite (greenstone). Flax and other leaf fibres, bird feathers, shells, hair and other materials were all put to some use. Red clays mixed with shark's liver oil provided a kind of paint. Vegetable juices and black mud yielded a limited range of dyes. Traditionally, ritual chants were made over the various tools to aid their effectiveness as working implements.

Human hands were the principal tools used in working soft materials, such as prepared flax fibre made from the leaf of the flax plant *(Phormium tenax)*. This plant served the Maori in many ways. Raw flax leaf strips had hundreds of uses, while the prepared fibres were used as the basic material of garments.

Maori life depended greatly on things made from wood. From common weeding implements to massive war canoes, wood was the material and was vital to tribal survival. The Maori lived as much in a wood age as in a stone age.

The principal tool of Maori culture was the wood-working adze. This consisted of a stone blade lashed with cords or split vine strips to a wooden helve. The size of this tool varied according to use. Some had massive blades weighing many pounds. These were swung with both hands by strong carvers who, with legs outspread, stood over the wooden slab that they were shaping. The smallest adzes were held in one hand, and the blades weighed only about 50 grams. The smaller implements were used in shaping such objects as treasure boxes.

The second most important tool of the woodcarver was the chisel. This consisted of a blade lashed to a short, wooden handle. These also varied in size, the largest types being struck at the end by a mallet of whale bone or wood, while the

maller ones were held in the hand. Chisel blades had either a straight cutting edge and resembled small adze blades, or were a gouge-type with concave cutting edge.

Blades were made of stone or bone. Human thigh bone, being dense in texture, was favoured. Nephrite (greenstone), the hardest stone available, was most valued as a blade material for both adzes and chisels. Obsidian flaked from the core of the material also provided sharp cutting pieces, which were put to many uses.

The Maori was a remarkably skilful worker of wood. Great trees were felled by adze, aided by burning. Logs were split by driving hardwood wedges into the cracks with heavy mallets. The making of a war canoe or a large house sometimes required years of prior planning by the community.

The only tool of rotary motion was the drill. This consisted of a stick shaft to which were lashed stone weights and a stone drill point. It was twirled by pulling two cords that were first twisted about the shaft. Then the craftsman, with balanced pulling on the cords, caused the drill to spin away. Of course this reversed its rotation constantly.

Holes were drilled in wood, stone, and bone on smaller objects by this method. In a land without metal nails, planks were joined with cord lashings passed through holes cut with chisels. Such holes were of square form. Wooden pegs were sometimes driven in after lashings were in place to help hold them firm.

Holes in stone were made by drilling in from each side. This process made two dish-shaped depressions, which met to form a hole. But the two impressions were rarely equally centred. Such uneven hole drilling is characteristic of old stone weapons and hei-tiki.

When metal became available to the Maori in the eighteenth century, it was usually in the form of ships' nails, hoop iron bands from barrels, and other miscellaneous objects. Ships' nails made good chisel blades while pieces of hoop iron were easily formed into adze blades.

In time, Maori craftsmen acquired a full range of European metal tools such as adzes, axes, saws, brace and bit drills, chisels, iron wedges, and hammers. The effect of metal tools on woodcarving art was dramatic. Wood was cut so easily, and with the advent of sawmills, boards and slabs were readily obtained. Storehouses, canoes, and meeting houses grew larger and more elaborate in decoration. Most of the large, impressive storehouses, all of the existing meeting houses, and war canoes seen in New Zealand museums were made in this era of steel tool craftsmanship. Stone and bone tool work are best seen in the smaller objects of Maori artistry, and in parts of old storehouses, houses, or canoes.

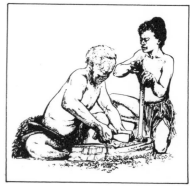

In this line drawing by Dennis Turner, a master-carver (tohunga whakairo) is attended by a devoted apprentice. Such neophytes were selected for training on the basis of their good birth and natural aptitude.

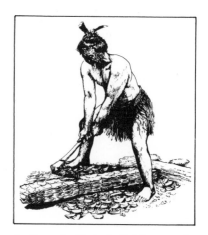

A stone adze blade, hafted to a wooden handle by flax-fibre cordage or bark strips, was the carver's basic tool. Here a craftsman stands over his work in order to swing a heavy blade. The smallest adzes were held in one hand. This pen sketch is by Dennis Turner.

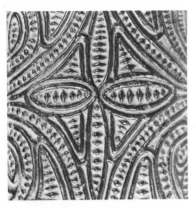

The character of surface decoration usually reveals the type of cutting blade used by the carver. Work with stone tools is usually softer and more rounded in the cuts, as seen in this detail from the lid of a treasure box (wakahuia) in the Webster Collection, National Museum of New Zealand.

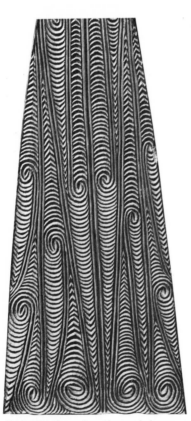

Sharp-edged steel tools used in most nineteenth-century carving — notably the V-bladed chisels — affected the character of surface cuts. The crisp carved decoration of this paddle blade exemplifies metal-cut designs on wood. The paddle is in the Wanganui Museum.

Wood

To the Maori, trees were the children of the forest god Tane. They clothed the body of the Earth Mother, to provide a home for the offspring of the gods — the birds, mankind, and all other creatures. Trees and vines had different properties and each was put to an appropriate use. Hardwoods were made into weapons and working implements. Woodcarvers found in the conifer, totara *(Podocarpus totara),* an ideal material for general carving work. It was abundant on high and low land, was readily split into long slabs, and was soft enough to be cut by adze and chisel. It was also durable, although it had a tendency to develop surface cracks when it was exposed to sun and rain.

The great kauri pine *(Agathis australis)* of the North Island provided an even finer wood for the carver, but its availability was limited to the northern regions about and above Auckland. Its straight, knotless grain, and its softness with strength made kauri one of the finest ship and house building woods in the world — a fact which led to entire forests of it being cut out in the nineteenth century.

Many other woods were selected for differing purposes. There is no need to list them here, as they are noted in the standard ethnographical books.

Bone and Ivory

Bone and ivory were important materials to the Maori. The whale, a creature that was not hunted because of its giant size, was occasionally found stranded. Such unlucky creatures provided a wealth of heavy bone, which was made into short clubs, cloak pins, fish hooks, fish threading needles, and other objects. The ivory teeth of the sperm whale and of certain other sea mammals were used as ornaments. The dense-textured wing bones of birds provided toggles for neck ornaments, tattooing combs, chisels and flutes. The dog also made its contribution as its strong curved jaw bone made fine fish-hook points.

The most prized bone was human. The fine-textured thigh bone and other long bones of the body were made into flutes, fish hooks and bird spear points. The use of the bones of a slaughtered enemy was utilitarian, and it also dishonoured the dead man and his living kin. This element of revenge, an emotion much savoured in traditional Maori life, was a frequent cause of war.

Shell

The shell of the paua *(Haliotis iris),* when cleaned of its encrusted lime coating, provided an iridescent material of brilliant greens and purples, used as eye or other inlay in

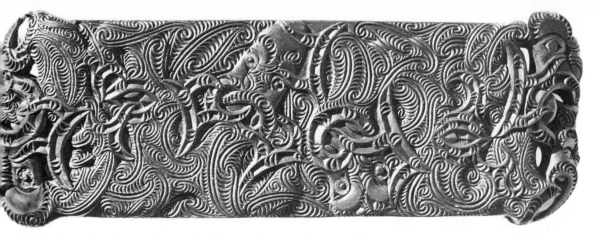

woodcarvings. Sections of paua shell were also used to provide a flashing, reflective surface on trolling hooks of the pa kahawai type. The strong rim of the shell was sometimes used as both shank and point of a two-piece hook.

In rare instances small paua shells were set whole as the eyes of tiki, however, the usual practice was to use only cut portions. The rainbow-like reflections of this shell are due to surface striations and not to a colouring pigment, so its brilliance remains unless the shell is dulled by weather exposure.

The bottom view of a dynamically carved treasure box from North Auckland (62 cm), presented to the Reverend Samuel Marsden early in the nineteenth century. The quality of such a carving, evidently stone work of the eighteenth century, is not to be surpassed. The author photographed this box in London in 1956. Present whereabouts unknown.

Flax

When the ancestors of the Maori reached New Zealand from the tropics, they no longer had access to the coconut palm, which had provided many useful products, including palm fronds for plaiting and husk fibre cordage from its abundant nuts. Another tropical tree, the pandanus, which also had many uses, was missing. Thus the Maori settlers were obliged to look about for substitute materials.

Many fibrous plants were found. The single most remarkable one was the flax plant *(Phormium tenax)*. It grew in abundance in many varieties, some having leaves two or more metres in length. Its leaves could be used raw as strips for many purposes, while their fibres, when prepared, were soft and strong.

To make such fibre the leaves were first selected and cut, stripped, and scraped with shells to remove any green matter. The fibre was then soaked, pounded, and bleached in the sun. The result was a strong pliable material that made excellent garments of many types, nets, fishing lines, and lashings to tie together the parts of houses, foodstores, canoes, or pallisades. Many other uses were also found for this wonderful plant.

In art work, prepared and bleached flax strips were plaited into mats, baskets, war belts, and other articles. Patterns were obtained by plaiting strips dyed in black swamp mud with undyed, bleached strips. A great variety of patterns was thus created.

Basket (kete) made from strips of contrasting bleached and black-dyed flax plaited into one of the many patterns used by craftswomen. This example is in the Auckland Museum.

The abundance of bird feathers of varied colours, shapes and sizes available to the Maori craft worker, plus the use in New Zealand of a technique for making strong flax fibre garments, led to a highly sophisticated range of feather cloaks. This detail of a cloak reveals its strong rectilinear pattern. Collection Alexander Turnbull Library, Wellington.

Feathers

Feathers of the multicoloured native birds of New Zealand were used in the decoration of fine cloaks. They were usually attached, feather by feather, during the process of making the basic garment from prepared flax fibres. Red parakeet feathers, along with small tassels of white dog hair, were often placed as a kind of ruff around the long club (taiaha) at its decorated end.

Small bundles of albatross feathers were fixed to war canoes at the point where the hull meets the top strake, and split hawk feathers were tied as trailing strings to the tops of the stern posts of war canoes. Feather bundles were attached to gourds containing preserved foods, serving at times as a label of contents. Also, feathers were used extensively as personal ornamentation by being thrust into the hair or as bundles suspended from holes pierced through the lobes of the ears. Even whole bird skins were so worn as ornaments.

Gourds

The Maori gourd (hue) was grown in gardens for food and for conversion to water vessels and bowls. In the latter case, when a gourd was mature it was selected for shape, then the soft inner flesh was removed, leaving only the shell or rind. This shell was then made into a vessel either by cutting it horizontally to form a bowl, or by making an opening at the top to form a kind of bottle. Some storage gourds had wooden necks attached at their tops, and some of this type were mounted on three legs. The legs were lashed to cane hoops tied around the gourd.

Some bowl-type gourd vessels were finely incised with koru patterns. Because of the fragility of gourd vessels, only a few have survived. Gnawing rats and mice regarded them as food. The decorated gourds were often objects of special beauty.

Gourds (hue), reduced to their rind by the removal of the soft inner flesh, made useful vessels of a number of types. Many were incised on their surfaces with decorations of koru type. This example is in the National Museum of New Zealand, Wellington.

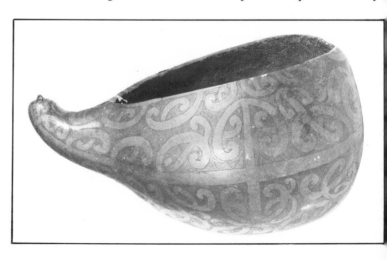

Hair

The absence of hairy mammals in New Zealand, other than the dog, rat, bat and man, gave little scope for the use of hair as an art material. The dog, white or tawny brown, provided hair for long club and cloak ornamentation.

Strips of dogskin with the hair still attached were sewn on to a heavy canvas-like flax garment made with knotting techniques related to those used in taniko work.

Human hair was not put to decorative use as it was on many Pacific islands, presumably because of Maori beliefs concerning tapu.

Colour

Applied colour in Maori art was limited to the use of prepared red and blue-white clays, sooty carbon pigments, dyes from swamp mud, and various concoctions from plants.

Bird feathers, greenstone (pounamu) and naturally brilliant materials gave some strong colour to Maori products. Prepared colours were few.

The most widely applied colour was that derived from fine, red clays, which was called, in prepared form, kokowai. This pigment was made only from selected ferruginous clays or haematite. It was gathered at sites where the clays were rich in iron oxide or ferric oxide. Certain districts were famous for their special red clays.

The raw material was mined, powdered, then mixed with water. It was then rolled into balls which were baked in fire or hot ashes.

A method of gathering a very fine pigment was to immerse fern fronds in water where floating particles of red clay would settle on them. These fronds were then gently lifted with their clay particles and shaken over a mat. When the clay sludge was dry enough, it was rolled into balls and baked.

It seems that nothing of value escaped an application of kokowai. The early traveller Bidwill complained that it was impossible to be 'carried by a native without getting one's clothes soiled by the "red dirt" which saturated their mats.' Kokowai was liberally applied to the body and so transferred to Maori garments, and as it was a regular custom for dressed Europeans to be carried ashore or across rivers by sturdy young Maori men, they too got ruddied.

Mixed with shark liver oil, kokowai formed a kind of unfixed paint that was often applied to carvings. Red was a sacred colour in Maori belief and was especially associated with the gods and high-born persons.

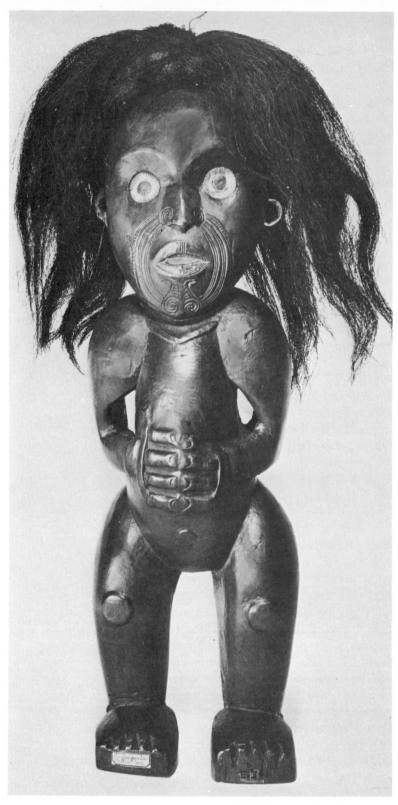

A free-standing tiki image with human hair attached to the head. Such figures, of which there are few existing, were probably placed at the base of interior house pots as representatives of ancestors. This figure stands 40cm. Collection of Hunterian Museum, Glasgow, Scotland.

Woodcarving Surface Patterns

Surface patterns were added to sculptured forms or they existed alone as decorations in their own right. The types of surface decoration are better illustrated than described. Photographs and line drawings tell us more than words.

Curvilinear surface decorations predominated in Maori woodcarving, mostly in the form of spirals. Straight line elements were often present but were less conspicuous. The single spiral or simple coil did not occur as a typical motif in Classic Maori art. The spirals that were used were complex double-looped or interlocked forms. Even triple spiral forms developed during the nineteenth century.

Spirals that were of a fretted 'aerial' form, such as in the open work of war canoe prow and stern carvings, involved specialised carving techniques. The term 'takarangi' — encircled glimpses of the sky — is a very expressive word for such a carving style. They needed strengtheners between parts of the main design, and these took the form of 'chocks'. At times these small connectors lost their structural function but were retained for decorative purposes, as on some frontal boards of carved houses.

Surface decoration varied greatly, yet certain conventions were adhered to by tradition. The range of cuts that could be made with stone age adzes and chisels was limited. This technical limitation determined, to a great degree, the range of spirals, notches, chevrons, zigzag lines, crescents, and ridges that could be formed.

Stated simply, there are four basic types of curvilinear and rectilinear surface patterns that were commonly applied. These are:

Rauponga: A series of dogtooth notches set between two, three

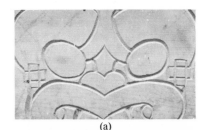

(a)

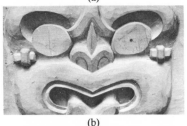

(b)

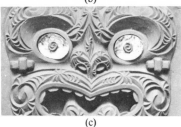

(c)

Three woodcarvings made in 1949 by I.C. Tuarau, then carver at the Dominion Museum. The three basic steps in twentieth-century carving are as shown:

(a) outlining of image by pencil or chalk lines, which are then grooved out with a V-chisel

(b) blocking out with adze and chisel the main sculptural masses

(c) addition of surface decoration by shallow cuts with chisel, followed by pigmentation of surface by paint mixtures or by wood stains. Shaped paua shell eyes are then placed in the eye sockets on the 'iris' knobs left for the purpose.

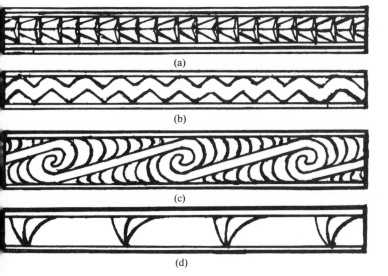

(a)

(b)

(c)

(d)

Basic types of surface pattern cut on wood:
(a) Rauponga with 'dog tooth' knotches (pakati) set between ridges
(b) Taratara-a-kai, a knotched zigzag set between ridges
(c) Pakura, a rolling interconnecting spiral pattern
(d) Unaunahi (or ritorito), likened to the scales of a fish.

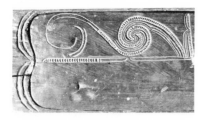

Unfinished surface pattern on a treasure box in the Hawke's Bay Museum, Napier. It illustrates the traditional Maori carver's practice of extending lines in what is called 'the mind's eye' to create a pattern. As far as is known, Maori carvers did not draw on wood in pre-European times.

or more parallel ridges. Such patterns were used commonly on house panels and elsewhere widely applied, particularly in the late nineteenth century.

Taratara-o-kai: Varied zigzag notchings that occurred with or without separating lines. They were usually carved in low relief and as a pattern appear closely associated with foodstore carvings.

Unaunahi or *ritorito:* Appeared as small crescents set in grooves. They radiated in groups from a point at the lowest part of the groove in which they were set, each group of the curving crescents being set about an equal distance from its neighbours. This type of surface decoration is often seen on eighteenth-century carvings.

Pakura: A pattern named after the swamp hen because of the fancied resemblance to that bird's footprint. These arrangements were long, rolling, looped, and interlocking spirals all set well apart. Elliptical crescent elements filled in the spaces above and below the line interconnecting spirals. This pattern reached a marvellous precision of cutting on certain treasure boxes.

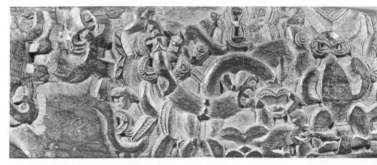

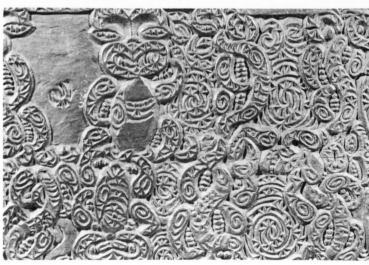

Woodcarvings in a semi-finished state, such as these two examples from one box in the Auckland Museum, show (above) the blocking out of a design after the box itself is made, and (below) the precise secondary carving cut over the main sculptural shapes.

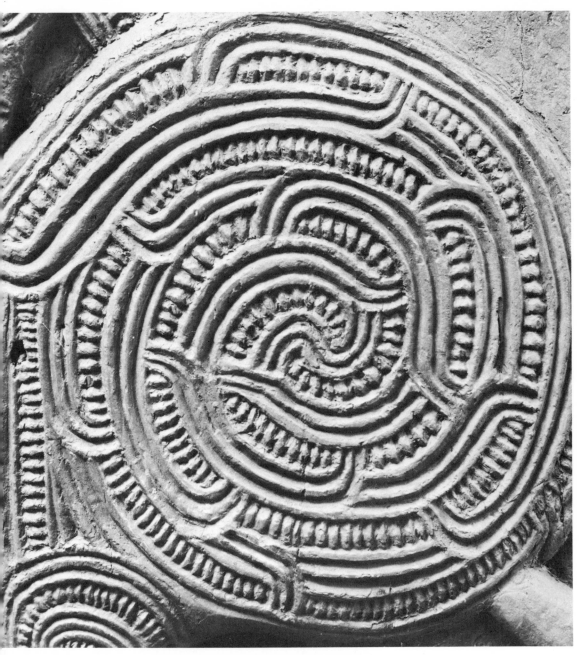

An ornate double-looped spiral, photographed at the shoulder of a large ancestral house panel from Taupo. The carver was from the Te Arawa region, Rotorua, Bay of Plenty. This steel tool carving has been softened by the clogging effect of many coats of oil-bound paint, much of which has been removed in restoration. Collection Hawke's Bay Museum, Napier.

Major Structural Arts of the Maori

Structural arts are those which involve the joining together of parts. In pre-European times the Maori had no nails, so large wooden objects had their parts lashed together by passing cord through holes cut in them by chisels. The Maori craftsmen did not use the type of joinery used by the carpenters of East and West. Nor was any attempt made to fasten parts together using wooden nails — a joinery method common to many traditional cultures. Wood pegs were hit into holes but only to help make lashings firm in Maori work.

The principal structural arts were three:

Naval architecture — notably war canoe construction.

House architecture — the erection of storehouses, superior dwellings, and meeting houses.

Fortified villages — the stockaded pa, which had palisades, tiki images and other fittings rooted in holes or held by lashings.

Undecorated canoes, houses, and modest villages existed and these too needed structural work, but here we are mostly concerned with the decorated items.

Canoes

Canoes were of three basic types: the small dugouts (waka tiwai) used on rivers, lakes, and sheltered coastal waters; the all-purpose canoes (waka tete) employed mostly in fishing and general conveyance; and war canoes (waka taua).

Canoes were, in pre-European times and up until about the 1850s-60s in the Bay of Plenty, the most valued of tribal possessions. The great war canoes were a special reason for communal pride. The manufacture of a great war canoe, some of which exceeded 30 metres in length, was an undertaking that involved years of preparation. When it was launched, ritual prayers were chanted and slaves sacrificed to sanctify the vessel.

Abel Tasman and Captain Cook both observed double canoes joined with beams in the tropical Polynesian manner, yet the type disappeared at the end of the eighteenth century.

Decorations of the surface of a paddle blade in the collection of the University Museum, Philadelphia, U.S.A.

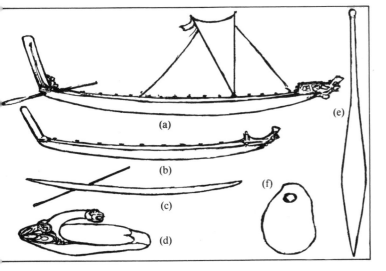

The canoe and canoe fittings:
(a) war canoe (waka taua) with set sail and steering oar at stern
(b) common coastal canoe frequently used for fishing (waka tete)
(c) dugout and unadorned lake and river canoe (waka tiwai) with punting pole
(d) canoe bailer (ta)
(e) ordinary paddle (hoe)
(f) simple stone anchor (punga).

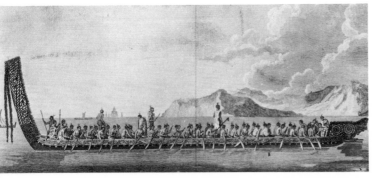

Engraving of a Maori war canoe off the East Coast of the North Island, at the time of Cook's first visit, from a drawing by Sydney Parkinson. The splendour of such fighting vessels greatly impressed the early visitors to New Zealand.

It was, it seems, revived in areas — about the stormy waters of the South Island — as nineteenth-century whalers reported seeing them.

The Classic Maori were not deep-water sailors as were their forebears. Their canoes became coastal vessels that relied on paddles for propulsion, not sail power. A sail was sometimes rigged to assist progress but only if the wind was favorable. Maori canoe travel depended on suitable weather conditions, and the captains and crews were prepared to wait patiently days or even weeks before making hazardous open water voyages such as the crossing of Cook Strait.

War and fishing canoes were made of five basic parts: dugout hull, washstrakes, bow and stern carvings, plus the cross thwarts that held the upper boards apart. Some of the longest war canoes had bow and stern sections fitted to the basic hull. They had various loose fittings such as paddles and bailers. If a sail of flax matting was carried, it was set well forward between two gaffs, which met in a hole cut for the purpose in a protrusion in the bilge of the canoe. The sail, when set, was controlled by a simple arrangement of a few line 'shrouds'.

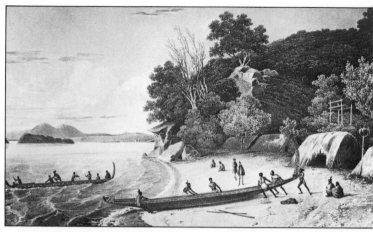

View of coastal fishing canoes, sketched in the region of Tasman National Park (Nelson) by an artist with the French maritime explorer D'Urville (1833).

The ornaments of a fishing canoe usually consisted of a mask set on the prow piece with a splash board carved from the same block. The angled stern board was usually plain. The war canoe, by contrast, was highly ornamented. Prow, stern carvings, washstrakes, and the various fittings were elaborately carved. Ornamental feather work was added in the form of tufts of albatross feathers set under the lashings where hull met washstrakes. Rods with attached feathers were thrust out over the prow ornament, while long streamers made from bundles of split hawk feathers trailed from the top of the sternpost.

Lizards were sometimes carved on a thwart near the stern to reserve it for the use of the commanding chief and others of authority who stood to chant and spur on the paddlers. The largest of vessels carried a hundred or more men, who were so co-ordinated in their paddling that the canoe moved through the water at a considerable speed.

The 'standard' Classic Maori war canoe is best seen today in the Auckland Museum. It is the only one preserved more-or-less intact. This great waka taua, named Te Toki-a-Tapiri (The Adze of Tapiri), was made in about 1836 at Whakaki Lagoon, near Wairoa, Hawkes Bay. It is 24 metres long and 2 metres wide at its greatest beam.

Prows and stern ornaments varied in style. A spectacular trapezoid prow type with elongated manaia forming the main design were made about North Auckland.

Prow of a fishing canoe. This example, which has some unusual elaborations on the sides, is in the collection of the Gisborne Museum.

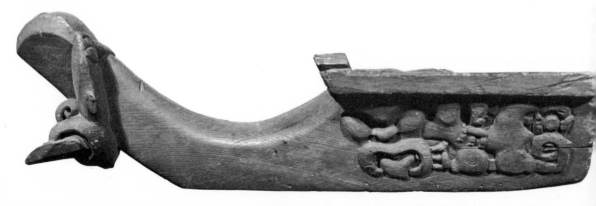

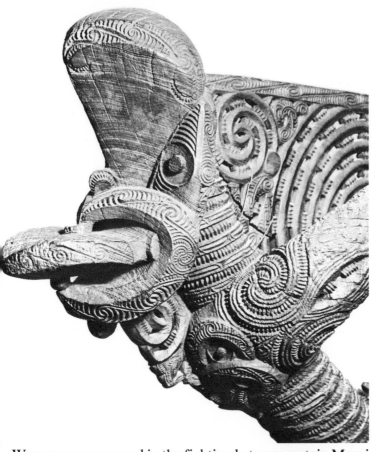

A head detail of a war canoe from Waitara, now in the Taranaki Museum, New Plymouth. The beaked lips, out-thrust tongue, and backswept arms shaped like wings give these prow figures a decided bird-man appearance.

War canoes were used in the fighting between certain Maori tribes and the Pakeha (with their allied tribes) until the 1870s. However, when those conflicts came to an end the working days of the Maori war canoe as a war vessel were over. Maori craft skill concentrated on the communal meeting house as a structure the new social conditions required.

Storehouse Architecture

The storehouse (pataka) ranged from small box-like structures set high on poles, to substantial buildings raised on four or more piles. Their purposes were to protect special foods or equipment from thieves, rats, dogs and dampness, and to enhance village prestige. They were usually of communal ownership and under sacred protection (tapu). Their decorations could be simple or complex. Some were ornamented only on their facades while others had carving slabs on all sides. Many storehouses had porches with large doorway panels and small entry holes so low anyone entering was obliged to crawl in. These 'doors' were fitted with slabs that were drawn across the entrance.

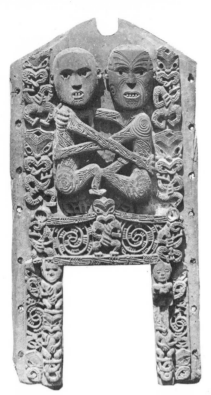

Door slab (137 cm) from a nineteenth-century storehouse of complex design. The knotched gap at its top is to accommodate the ridge beam of the structure. This example is in the collection of the Canterbury Museum, Christchurch.

The ornamental carvings of storehouses were external because they were seen from the outside of the building. This is a contrast to the meeting house, which had most of its carved work inside for the simple reason that it was occupied inside.

In Classic Maori times storehouses were a source of village pride ranking second only to the war canoes. They assumed a special symbolic importance in the King Movement. However, economic changes brought about by the introduction of European crops, particularly the potato, and methods of building with saw-cut timbers, changed the role of the storehouse just as it had done that of the war canoe.

Taranaki swamps have yielded many fine storehouse carvings in recent decades. It was a custom to remove the finest carvings from the storehouses and hide them from depredation, either by immersion in swamp mud or other means, on the approach of a powerful enemy. When the northern tribes raided Taranaki early in the nineteenth century, many carvings went into the swamps. As fate would have it their owners either perished in war, fled the district or were taken into slavery. The precious storehouse parts have been recovered in part as swamp drainage ditches have been dug in recent times.

Many large storehouses were built in the middle to late nineteenth century. Yet their position as a focal point of tribal pride declined just as had that of the war canoe. The need for them steadily diminished as European architecture (e.g., barns and storesheds), new crops such as the hardy potato, and animal husbandry changed the basic economy of Maori life.

A new need arose. Large meeting houses where political and community discussions could take place and guests could be received gained prominence and, incidentally, had a dramatic effect on Maori visual arts.

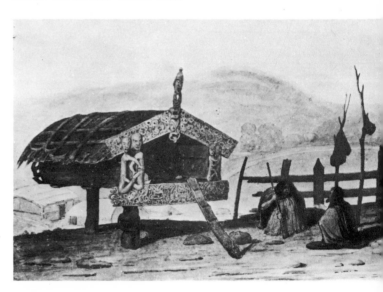

An ornate storehouse sketched by the traveller-artist Augustus Earle, who visited New Zealand in 1827. Most of his works are of subjects in the Bay of Islands and other North Auckland districts.

orge French Angas came to New Zealand in 1844 and
velled to many remote Maori districts of the North
and. A large album of lithographs by W. Hawkins
de from Angas's sketches was published in London
1847, under the title *The New Zealanders Illustrated*.
is book remains a most valuable record of the New
aland Maori of the 1840s. Angas was to some extent
ected by Victorian sentimentalism and tended to depict
 Maori as a noble savage, but he was certainly a fine
ist, as these reproductions indicate.

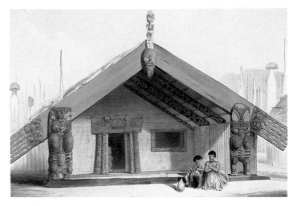

House on the island of Mana, adjacent to Kapiti Island. This
house, named 'Kaitangata', was the residence of the Ngati Toa
chief, Rangihaeata.

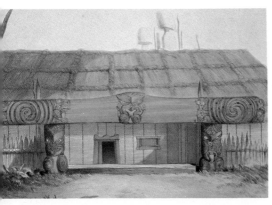

use at Raroera Pa, situated about four miles from Otawhao
r the Waipa River. This house is notable for its side entrance,
tured here, as front access to a house was usual.

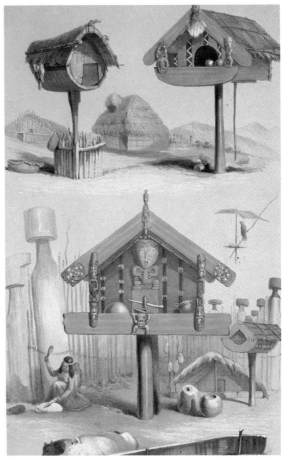

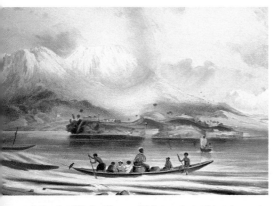

iew of the fortified village of Motupoi, looking towards
ngariro across Lake Rotoaira. In the foreground a party of
oris in a canoe have with them a captive kaka parrot, possibly
wler's decoy, sitting on a stick at the prow.

Three storehouses of varying designs, used to protect precious
foods, seed tubers and treasured objects from the depradations
of humans and rats.

Sectional details of plaited baskets. A wide range of patterns was obtained by crossing black-dyed and natural bleached flax strips. An orange colour was obtained by using pingao grass.

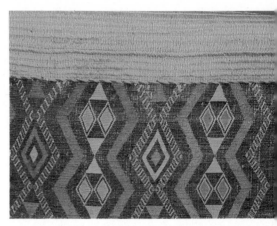

A detail of a section of a plain flax fibre cloak with ornamental taniko border. Cloaks of this type were termed 'kaitaka'. The pattern, in this instance formed by knotting with the fingers, combines zigzag and triangular motifs.

A sectional detail of a taniko cloak border illustrating a comp: pattern of lozenges, triangles and zigzag lines. The colour in t: fine old example was derived from vegetable dyes.

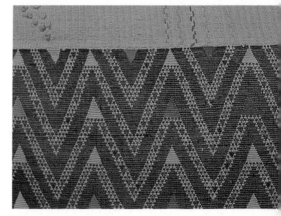

A taniko cloak border of natural dyed colours with so: oversewing of portions using chemically dyed European threa: Such tasteful combination of old and new materials is a trib: to Maori craftworkers.

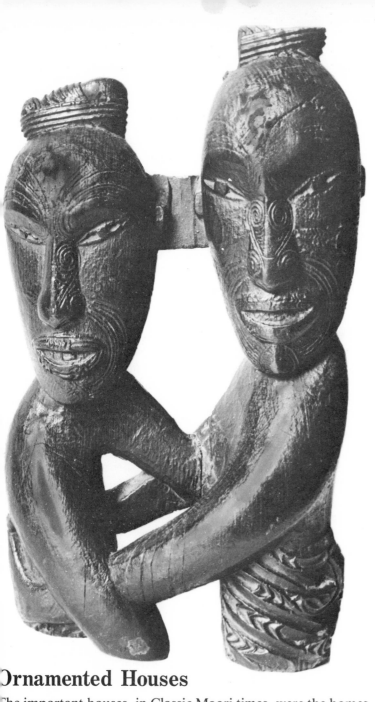

This singularly beautiful woodcarving from the facade of a North Auckland storehouse shows a man and a woman in loving embrace, and is similar to those on the storehouse painted by Augustas Earle. The author photographed this carving in London in the home of K.A. Webster in 1956, however it present whereabouts is unknown. Unfortunately the carving was cut by saw at waist level, probably by the original collector. Such desecrations were common in the nineteenth century.

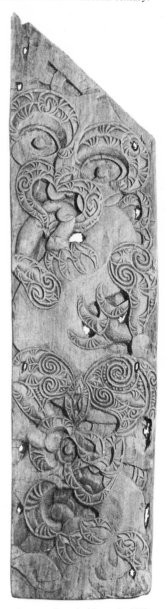

Storehouse facade board (137 cm) recovered from a Taranaki swamp. Collection of the Taranaki Museum, New Plymouth.

Ornamented Houses

The important houses, in Classic Maori times, were the homes of the seniors of the tribe or sub-tribe. They were used as the dwelling places of hereditary chiefs and their immediate families, as meeting places, and occasionally as places of accommodation for special guests. Such houses, of several types, were set about the marae — the open meeting ground where all gathered to discuss affairs and to listen to the oratory of the chiefs. On such occasions women and children were silent onlookers.

The parts of the facade of typical nineteenth- and twentieth-century Maori meeting houses. The line drawing, based on Te Hau-ki-Turanga in the National Museum of New Zealand, is from the author's guidebook to that fine house.

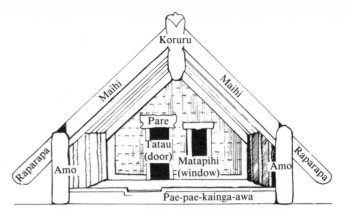

Koruru
Maihi
Maihi
Raparapa
Raparapa
Pare
Amo
Tatau (door)
Matapihi (window)
Amo
Pae-pae-kainga-awa

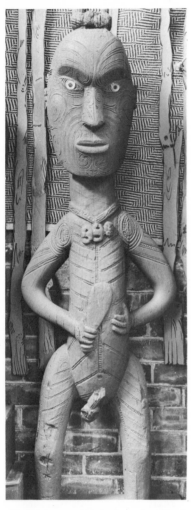

Above: Ancestral figure from the palisade of a fortified pa of the East Coast region. These figures served to express tribal defiance and as magical protective tiki. They were carved on a heavy pole, the base of which was set in the earth as part of the defensive palisade. This large figure, which stands 170 cm, is in the Hawke's Bay Museum, Napier.

Right: Before about 1830 most houses were rather humble. The decorative carvings of this time were usually limited to door, gable, and occasional interior ancestral images. The sketch of a North Auckland chief's dwelling is by Augustus Earle.

The lintels and other house carvings from the pre-European era are usually of a relatively small size, indicating that the houses they came from were also modest in size. The largest lintels belong to the post-European era.

Sketches from the time of Cook illustrate that houses had doors so low that those entering crawled in. The nineteenth century houses drawn by the artist George Angas in the 1840 show that post-European dwellings were 'growing' in size.

With this evolution of the house came the elaboration of carved panels depicting ancestors, painting of rafter surfaces and lattice-work panels set between the wooden wall slabs. Traditional Maori houses were designed to meet the need for protection from weather, and to give warmth. The source of light or heat after dark was by one or more small fires set in stone hearths on the earthen floors. Rushes and mats provided bedding.

Houses of superior types were designed with a certain symbolism in mind, representing the body of a tribal ancestor. The ridge was the backbone, the rafters the ribs, the slanting facade boards his outstretched arms, while a pinnacle mask was the ancestor's face. The section of the ridgebeam over the porch often had two figures, male and female, usually in sexual

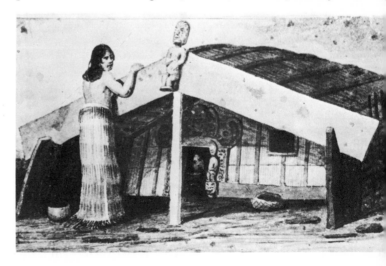

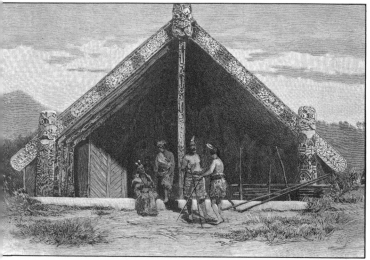

A famous house situated at Te Kuiti and called Te Tokanga-nui-a-Noho, illustrated in the *Picturesque Atlas of Australasia* (1886). This house was built for Te Kooti and his followers for Ngati Maniapoto, in acknowledgement of help received when Te Kooti was pursued by Government forces in the wars of the 1860s-1870s.

nion, which depicted the Sky Father (Rangi) and the Earth Mother (Papa). In the porch and within, the serried rows of ancestral panels set along the walls, and the standing figures of the support poles, depicted particular ancestors.

How much interior decoration pre-European houses possessed is uncertain, yet some extant ancestral panels indicate they were used. How much rafter painting or to what extent decorated lattice panels were set between ancestral slabs unknown.

What is certain is that by about 1830 the best houses had both painted rafters, with designs based on the koru motif, and elaborate lattice panels of various patterns.

Lattice Panels of Meeting Houses

Lattice panels — tukutuku — were formed from crossed stalks or laths held together by decorative stitching with strips of flax or grass. The front patterns were formed by a varied arrangement of cross stitching. The horizontal 'sticks' faced the viewer, while the vertical parts at the back were unseen. At times, especially in older examples, a central vertical runner was added to the frontal part of the panel both to add strength and to enhance the patterns.

These panels could be made either inside or away from the house. They were made to the size of the space to be closed between the wooden wall posts.

The yellow flower stalks of toetoe grass were used both front and back in early nineteenth-century panels, then machined laths of wood became more popular than the stalks.

Tukutuku craftworkers set up a frame to the required size then worked in pairs. Women commonly did this work. One stood before the panel, the other behind. Between them they

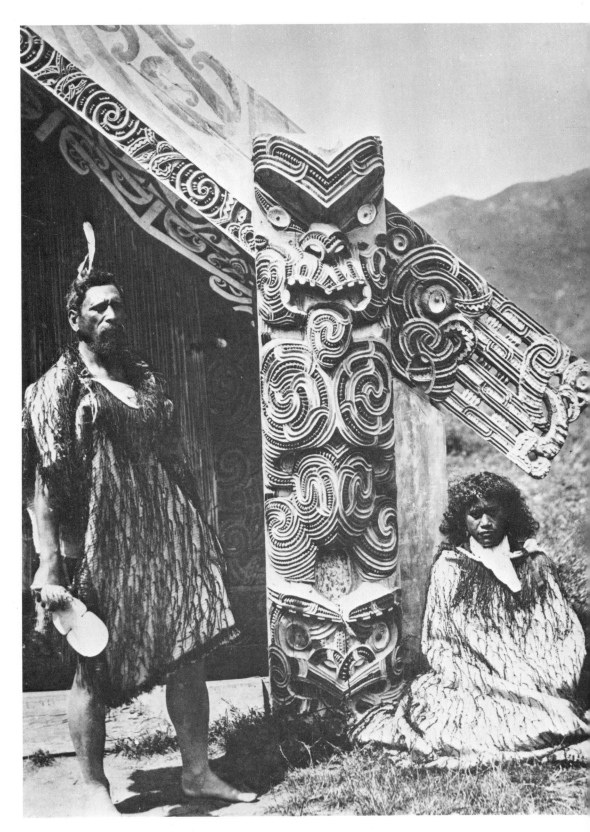

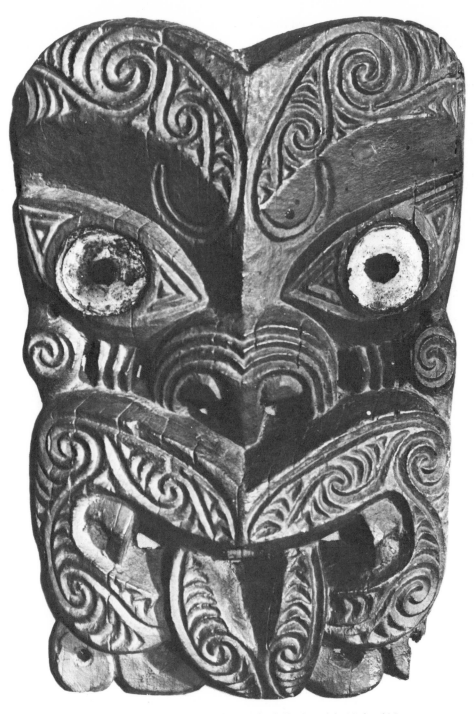

Gable peak mask (koruru) in Bay of Plenty style. Collection of the National Museum of New Zealand.

Opposite: Standing warrior and a woman before the side of a house at Te Wairoa, Tarawera. The carvings are painted in differing colours in the manner of late nineteenth-century decoration. This 'polychrome' style of work was to a large extent lost when the fashion of over-painting red European paint was widely adopted.

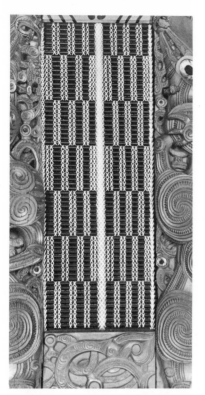

Lattice panel (tukutuku) from the Te Hau-ki-Turanga ceremonial house in the National Museum of New Zealand. This particular design is called 'albatross tears' (roimata-toroa). A set of panels from this house is to be seen in the colour plate section of this book.

laced the vertical and horizontal pieces together, with the person in front controlling the design by passing through the interstices of the crossed strips varied materials according to the choice of pattern.

The vegetable materials — the sewing strips — were of bleached or black-dyed flax, orange tinted pingao grass, or leaf strips of the kiekie vine that had been bleached to plain white. Other materials have been used, including multicoloured paints for the horizontal laths. Black and red paints are most traditional.

Later work often included tiki forms, flowers, Christian crosses, and pictorial subjects, all of which are of interest in the study of folk development in Maori visual art. Here we shall confine our description to a few standard patterns, namely those represented in the Te Hau-ki-Turanga meeting house, restored under the supervision of Sir Apirana Ngata in the 1930s. These were named according to some resemblance to a natural form, or an idea derived from a pattern, e.g., the stepped pattern became 'Stairs to Heaven'.

All patterns were based on the dispersal of cross stitches.
The principal designs are the following:

Kaokao: 'Human ribs'. This pattern suggests multiple ribs rendered in the manner of the Pacific art 'stick man'.

Patiki: 'Flounder'. A diamond-form pattern which resembles the form of the sand flounder — a common fish of New Zealand shores and estuaries.

Niho taniwha: 'Teeth of the monster'. The chevron forms of this pattern suggest the teeth of taniwha — the fabulous monster of Maori mythology.

Roimata-toroa: 'Albatross tears'. This design is composed of vertical sets of stitches set in squares.

Poutama: 'Steps'. This design, sometimes referred to as 'Stairs to Heaven', is said to symbolise the steps by which the demi-god Tawhaki climbed into the Maori heavens.

Mangoroa: 'The Milky Way'. The regular white cross stitches suggest clusters of stars, hence the name.

Waharua: 'Double mouth'. This pattern has no clear explanation.

Domestic Crafts and Maori Economy

Maori survival depended on sufficient military strength to face belligerent neighbours. The cultivations and food-yielding areas of coasts and forests within territorial boundaries needed guarding against trespassers.

The weapons used in battle are described in the chapter on personal regalia. Here we shall consider the ornate objects of the peaceful pursuits of fishing, fowling, and gardening.

Food Supply and the Visual Arts

Wild or cultivated foods were obtained by hard work, skill, and use of appropriate implements. Coasts, lakes, streams, rivers, and forests within the limits of tribal or sub-tribal territories were foraged for anything consumable. The root of the bracken fern aruhe was available in most places, a starchy, staple food available in all seasons.

An oil painting by Gottfried Lindauer in the Auckland City Art Gallery, showing the communal planting of the sweet potato (kumara) using the digging stick (ko). All gardening was highly organised in terms of labour, seasons, phases of the moon, and religious rituals aimed at securing the help of gods and fertility spirits.

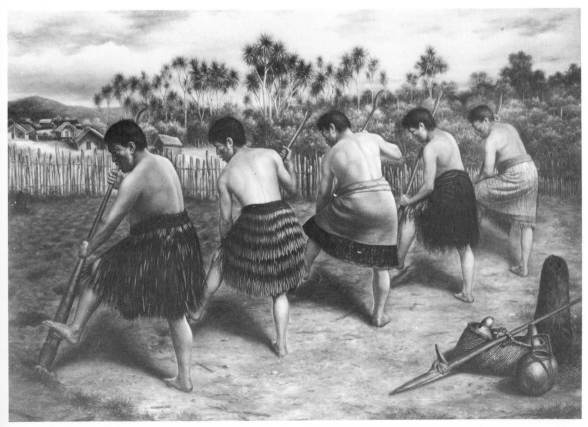

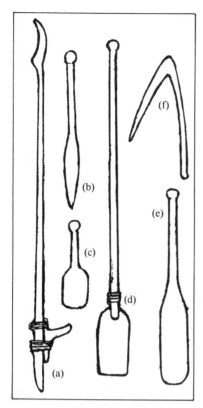

Basic types of wooden horticultural tools:
(a) digging stick (ko) with lashed on step (teka)
(b, c, d, e) small paddle-shaped grubber and spades
(f) a form of a grubber made from the fork of a small tree.

Classic Maori culture and art were, to a great extent, made possible by the efficient gardening of crops. The sweet potato, (kumara), taro, yam (uhi), and gourd vine (hue) ensured predictable food supply. Of the cultivated plants, the sweet potato was the most important, yet as it was of tropical origin it needed careful tending and storage in New Zealand's unpredictable climate. It was largely replaced by the potato after the advent of the European and his new crop plants.

The decorative art objects of gardening were the implements used in the ritual planting of crops and at the initiation of harvesting.

The most remarkable of these religious gardening tools were long digging sticks with elaborate ornaments carved at their tops, and lashed-on steps of tiki form. Digging sticks were pressed into the earth with the foot much as one uses the modern metal spade, so step projections were necessary.

Gardening rituals were aimed at appeasing the gods and spirits that controlled the fertility of gardens. Magical objects in the form of stone crop gods, ancestral bones, skulls, and mummified human heads were also used to this end. Rongo, the god of fertility, was the deity most honoured. Rongo's protection and good favour were vital to successful crop cultivation. Some digging sticks had a crescent ornament on top representing the moon, which related to fertility in Maori religion.

The ordinary gardening tools were plain grubbers, clod breakers, digging sticks, weeders, and such implements.

Fishing

Fishing was an ancient occupation that helped to sustain the Classic Maori and his ancestors for thousands of years. It was, like gardening, a sacred activity. However, rituals in relation to it were directed to another deity, namely Tangaroa, god of the sea. Fishing was a man's occupation. Women did not join fishing expeditions but foraged shoreline and rivers.

The equipment of open-sea fishing consisted of a canoe, a variety of nets (kupenga), lines (aho), hooks (matau), fishing rods (matira), and traps (hinaki). Scoop nets with handles, baited bag nets, and set nets were among the many specialised fishing devices.

Flax fibre served as the raw material for most lines and nets. Traps were mostly formed from the aerial roots of the kiekie plant *(Freycinetia banksii)* or the mangemange *(Lygodium articulatum)*. Fishing was not only an occupation of open seas, but also of coasts, rivers, lakes, and streams.

The fishing equipment of decorative interest was that associated with ritual magic. In initiating fishing seasons,

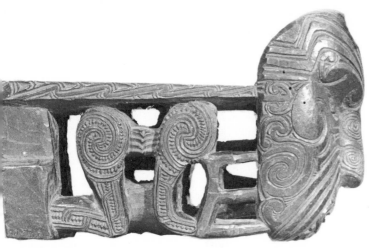

Specialised forms of digging sticks had at their tops elaborate carvings of symbolic significance and step parts (teka) that were usually in the form of a tiki image. This step is in the National Museum of New Zealand.

ornate versions of the utilitarian artefacts were used by priests qualified to preside.

The decorative aspect of the larger wooden-shanked hooks was their added masks and small tiki images. Even the smallest one-piece bone hooks often had masks of the manaia-type carved on them where the bait was tied on. Tiki-form net floats and sinkers had this magical association.

A curious freshwater dredge (kapu) was formed of a wooden frame with tiki at the outer ends. Such rakes had a net bag attached to the crossbar and wooden stakes along the main bar which acted as 'teeth'. When the gadget was drawn along the lake bottom at the end of a pole, it scooped up shellfish. They were used in the lakes of the Rotorua-Bay of Plenty region.

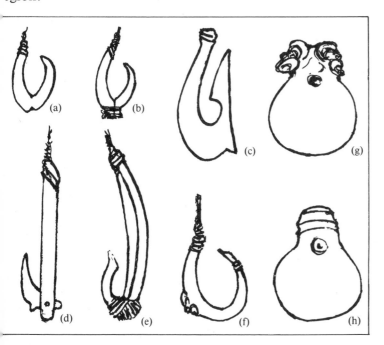

Items of fishing equipment
Cordage for lines and nets, wooden floats, net sinkers, traps and such paraphernalia were vital to the fisherman. Fish hooks and some sinkers, such as the types illustrated, are in themselves objects of miniature sculpture.
(a) one-piece bone fish hook (matau is the general word for a fish hook)
(b) two-piece bone fish hook
(c) large bone fish hook with inturned barb
(d) barracuda hook with wooden shank and bone point
(e) composite trolling hook with concave wooden shank, paua shell 'flasher' on the side of the shank, and bone point
(f) large wooden-shanked two-piece fish hook, with bone point. Small saplings were tied and forced to grow in a curve to provide strong shanks for such hooks, some of which were large enough to take a shark.
(g), (h), stone sinkers

73

Fowling

Birds (manu) of land and sea were very important in many areas of Maori life. They were a source of flesh food, and yielded useful bones and an abundance of feathers. They were the children of the forest god, Tane, so deity was duly respected. A fowler offered to Tane the first bird of his catch.

The forests of New Zealand formerly teemed with bird life. Flying and ground-walking birds abounded.

The densely textured wing bones of some birds, notably the albatross, were useful in making necklace toggles, tattooing chisels, combs, flutes, shell pickers, and needles. The wood pigeon (kereru), parrot (kaka), parson bird (tui), bell bird (kokomako), parakeet (kakariki), kiwi, and wood hen (weka) all provided flesh and particular products.

Birds were caught by snares and other devices. Some were caught by setting wooden water troughs. Thirsty birds, particularly pigeons, were tempted to take a drink from such troughs duly baited with berries and were snared by the neck.

Spearing was accomplished by poles set with harpoons with barbed bone points, which fell away attached to a cord when the point entered the body of the bird. Wooden spears, some of great length, were also used by fowlers in a direct thrusting technique.

A perch snare (mutu) lashed to the top of a long pole or placed in a tree was an ingenious invention. A noose, loosely held by quills or twigs set into holes on the perch, had a handcord which ran down to the fowler. When the bird alighted to eat the berries tied to the perch, the fowler merely pulled the cord, which caught his prey about the legs. The images carved on the shank and outer ends of such perches had a magical power and have a visual art interest.

Tame parrot decoys called timori were placed on the carved perches (turuturu). Many of these perches are objects of particular beauty. Some have seed and water cups at their ends. Such decoys had a leg ring (poria) made of bone or jade, which tethered them by a cord to the perch.

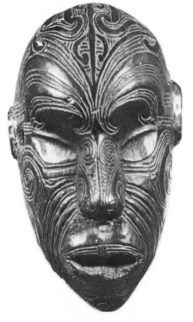

Elaborate perch used for a captive bird, which probably served as both decoy and family pet. Small cups at both ends of the perch served as seed and water holders. The end mask of this fine eighteenth-century carving is shown in its frontal aspect. This perch is in the Auckland Museum.

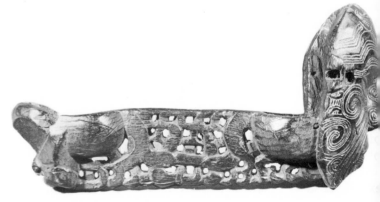

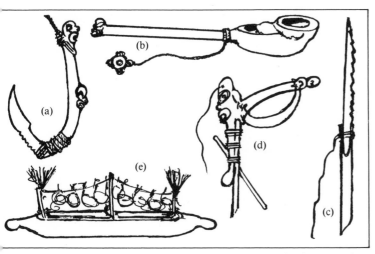

A hook for catching sea birds was composed of a wooden hank with a sharp bone point. This hook was baited with a piece of fish or offal, then cast from a canoe. Hook and bait were gobbled down by some voracious gull or other large sea bird to be quickly hauled aboard the fisherman's canoe.

Many other fowling devices existed, but they were not decorated.

Mat Making and Basketry

Things plaited from untreated or unprepared flax leaf strips were indispensable in everyday domestic life. Of these many items, mats and baskets of various types and grades were made by women.

Such goods ranged from the rough field baskets to finely worked mats with decorative designs worked into them. Baskets or platters of unscutched flax strips for a single use were quickly made, but fine plaited work required time and trained skill.

The degree of fineness of plait was determined by the use intended for a particular mat or basket. The principal technique was to work the stripped elements from a commencement edge, interlaced obliquely, to right and to left. Patterns were obtained by changing the numbers of wefts crossed. Black-dyed strips contrasted with the undyed bleached strips, which ranged from a warm amber to a whitish colour. The non-neutral elements, traditionally of black strips dyed in swamp mud, allowed the production of a variety of named patterns. These were developed by this simple process of overlapping and underlapping the dyed or naturally coloured elements. Some of the finer woven mats and baskets had another colour element obtained by using the yellow pingao grass leaf.

A strip of sample patterns which was made by a Rotorua expert, Te Ikapuhi of the Ngatipikiao, for Augustus Hamilton,

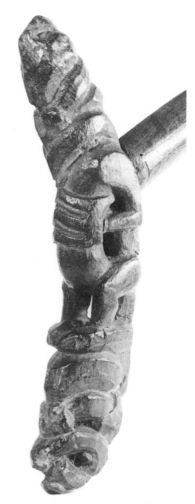

Ritual chants and carved symbolic images were much used in Maori fowling. Shown here is a tiki image standing on a mask on a snare perch, Webster Collection, National Museum of New Zealand.

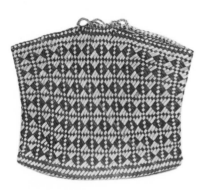

A superior type of kete or carrying basket in the Auckland Museum. A detail of this basket is shown in the colour plate section of this book.

Maori women usually worked in groups when plaiting the mats or baskets which were the common containers of everyday use. Green flax strips were quickly made into small baskets (kono), while more permanent containers of this kind were often elaborately decorated. The study is an oil painting by Gottfried Lindauer in the Auckland City Art Gallery.

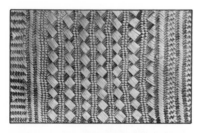

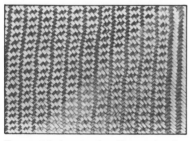

Two mat designs produced by overlapping natural bleached and black dyed flax strips. These are from a long strip of sample patterns by the nineteenth-century Rotorua expert, Te Ikapuhi of the Ngatipikiao, for Augustus Hamilton, the director of the Dominion Museum.

then director of the Colonial Museum in Wellington, provide a range of named patterns. These are illustrated by Hamilton in his classic *Maori Art,* published in 1896. This valuable set of plaited work is in the collection of the National Museum of New Zealand, Wellington.

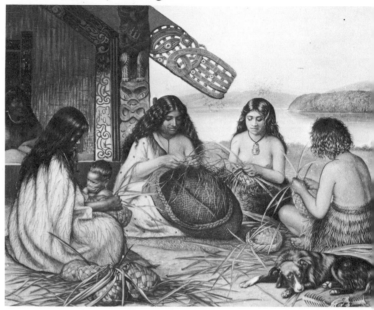

Household Vessels

Maori bowls were fashioned from a single block of wood or from gourds and, rarely, from stone. Their forms vary according to their basic materials. Wooden bowls have the greatest variety of form. Gourd vessels occasionally have incised koru patterns.

Maori houses had no flat-surfaced floors, tables, or sideboards. Bowls and other items were designed to be set on uneven surfaces or to be suspended from rafters or hung from walls.

As the Maori had no ceramic or metal bowls which could be heated over a fire, water was heated or fat melted in wooden vessels by placing hot stones in them. Fat was also caught as it dripped from a bird being roasted on a spit. Some wooden bowls had a grooved spout to permit melted fat to be poured into particular gourds. The accumulated pots or special storage gourds containing delicacies, which at times included human flesh, were placed in a storehouse until some special feast required their opening. The relish of some flesh was needed as the basic diet of starch foods became monotonous.

The display of these potted foods showed to guests the wealth and generosity of their hosts. They were objects of pride. Such potted goods also served as gifts presented to hired craftsmen. There was no currency in traditional New Zealand.

Some domestic wooden bowl and gourd types:
(a) gourd with three wooden legs and a carved neck piece. Special foods, particularly precious flesh foods, were preserved in such prized containers. They were placed in food stores to await special feasts
(b) bowl-like gourd
(c) gourd with open mouth sufficiently wide to admit a hand
(d,e,f) domestic wooden bowls were of many shapes to serve various purposes. The centre one (e) has a spout used to pour off melted fat or other liquids.

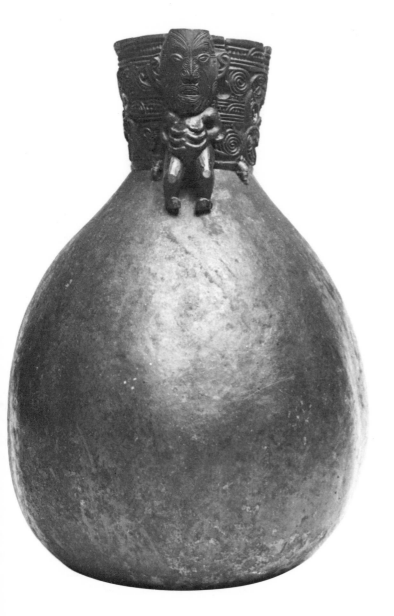

Gourd with a wooden neck piece in the Wanganui Museum. Such gourds were used for the preservation of special foods, such as birds and rats set in their own fat.

Personal Arts and the Chiefly Class

A number of Maori arts were 'personal arts'. They were those arts directly associated with the individual's special needs. Maori pattern and design reached an exquisite artistry in many of these intimate things, which are such a contrast to the impressive creations of communal effort, such as the war canoes, storehouses, and meeting houses.

Personal Arts Explained

The adornment of men and women of rank was an important matter of tribal concern as it was in chiefly persons that the prestige (mana) of the group was centred. The adornment of the high-born required the services of craft specialists. The best tattooer, makers of fine garments, weapons, ornaments and other things were sought after. No one begrudged generous payment in hospitality and goods to these experts. Chiefly people themselves were often the producers of some sort of fine art objects, yet specialists were always needed.

The durable items of Maori personal adornment were either worn or carried. Ornaments of various kinds were draped about the neck or suspended from pierced earlobes. Combs decorated the head. Personal decorations not only enhanced the appearance of men and women, but many had a protective magical function. Treasured personal amulets were often family heirlooms of considerable mana. Some passed from generation to generation, were venerated and given personal names. They were thought of as living entities.

In Classic Maori times the most evident personal ornament was the hei-tiki made of jade or other material. Hei-tiki represented ancestors. (The transitive verb 'hei' means to suspend.)

Hei-tiki made from nephrite were valued both as heirlooms and because of the precious nature of the material, which was rare in itself and shaped only by the laborious process of grinding with sandstone cutters.

The spiritual value of hei-tiki increased with successive ownerships. In pre-European times the custom of exhuming

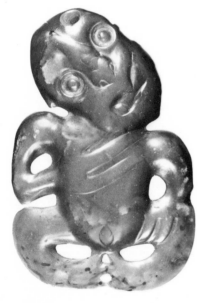

Hei-tiki are so varied in form, size, stance, regional style and colour that no single specimen exactly resembles another. Classic Maori hei-tiki are generally of the two types illustrated here. This flattish type is regarded as East Coast because it shares characteristics of the woodcarving style of that area. K.A. Webster Collection, National Museum of New Zealand.

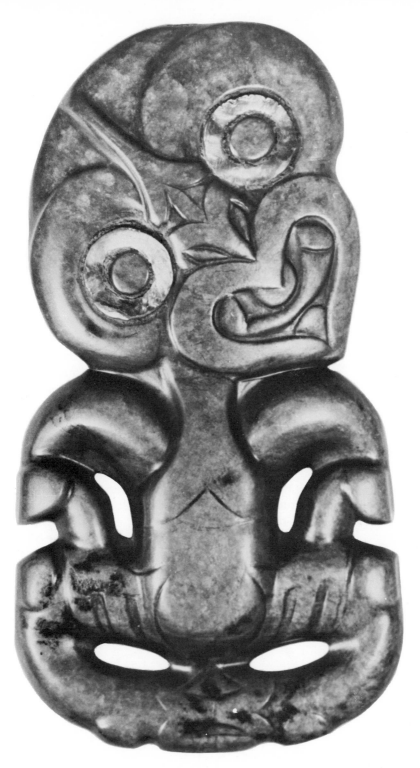

Greenstone was used in the manufacturing of a wide range of ornaments. The best known of these is the ancestral pendant 'hei-tiki', which was hung around the neck close to the throat of the wearer. A hole was drilled at the top of such ornaments, although they were occasionally suspended by means of the arm hole. This fine large example with paua-shell eye inlay measures 16.8 cm. National Museum of New Zealand.

bones and personal possessions, including hei-tiki, and passing these possessions back to the living increased their magical power.

The neck cords of hei-tiki were usually fitted with a toggle made from the wing bone of a bird, which slipped through a loop at the end of the cord. The cord was of such length that it brought the ornament close to the throat. Some hei-tiki have eye inlay of iridescent paua shell, which was, in post European work, often fixed into place with red sealing wax.

The variety of size, form, and colour of hei-tiki is remarkable. The smallest specimens are the size of a mid-thumb joint while the largest are the length of an outstretched hand.

The pendants of jade that were worn at the neck or from the ears were of five principal types: the slim, straight or curved form (kuru or kapeu); stylised fish hooks (hei-matau); coiled eel-like forms (koropepe); manaia as a single creature or double-headed (pekapeka). Sea monsters, the marakihau, were also shaped in greenstone.

Small chisels and adzes were often so precious to owners that they had small holes drilled in them so that they could have a dual use, as tools and ornaments. Jade parrot leg rings were also made, some being worn as ornaments.

Mammal teeth were favoured as pendants. Those of particular art interest are the large sperm whale teeth carved into a concave shape with incised eyes and nose at the lower end.

European visitors from the time of Captain Cook onwards had a great desire for curiosities to take home. Hei-tiki were much favoured and were collected both for their beauty and portable size.

As metal began to replace the jade adze blades, the Maori, anxious to trade, converted many jade blades into hei-tiki. Many hei-tiki reveal their adze origin by their shape.

Basic types of Classic Maori ornaments. (Greenstone was the material used for the best of ornaments, but ivory from the tooth of the sperm whale was also much valued).
(a) the hei-tiki ornament with neck cord and bird wingbone toggle
(b) manaia-headed coiled creature forming a koropepe
(c) a stylised fish hook (hei-matau)
(d) parrot leg ring (poria) of practical and ornamental use
(e) a double-headed pekapeka, resembling in outline the small native bat which is so named
(f) a rei-puta made from the tooth of a sperm whale
(g) straight drop pendant (kuru)
(h) drop pendant with curved end (kapeu).

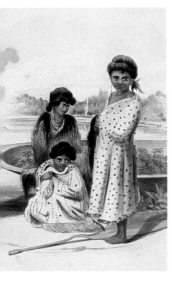 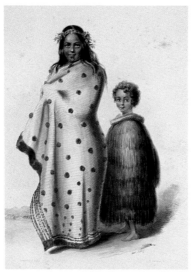 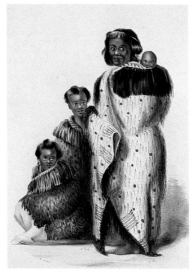

e children by a canoe, sketched by
as at Hopetui village. The cloaks are
rated with pompoms and thrums.

Angas described this charming pair as
'Ngeungeu and her son James Maxwell',
and added she was daughter of Tara, the
principal chief of the Ngati Tai of the
Auckland district. Ngeungeu married the
Waiheke Island trader Thomas Maxwell,
who was later lost at sea. She is seen in a
flax cloak with red pompoms. The boy
wears a heavier type of garment.

A woman with cloak decorated with red
pompoms and black thrums carrying a
baby in the traditional Maori manner and
accompanied by two children. Angas
identified them as 'E Pu and her children'
of the Ngati Toa (Cook Strait) people.

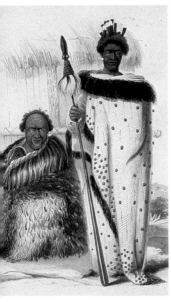 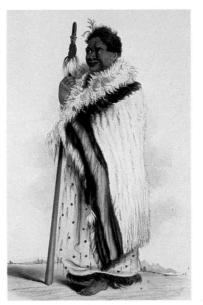 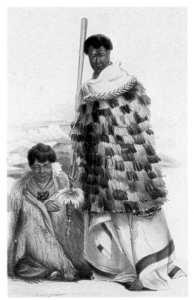

stately chiefs wearing fine cloaks.
as informs that these warriors were Te
ru, principal chief of the Ngati
kura, and Te Pakaru, principal chief
he Ngati Maniopoto tribe'.

The great fighting chief Tamati Wake Nene
(the two forenames transliterated mean
'Thomas Walker') was sketched by Angas
at Hokianga River. Nene was of the Nga
Puhi people; an influential leader and
protector of missionaries and of Pakeha
settlers in general. Here he is shown
resplendent in a dogskin cloak of white,
brown and black skin and hair strips sewn
on a base fabric. He holds a long club
adorned at one end with red feathers.

The man standing wears a cloak with a
squared pattern. He is described by Angas
(1847) as Mungakahu, chief of Motupoi
Pa, Lake Rotoaira, with his wife. Munga-
kahu holds a taiaha, and Mt Tongariro is
to be seen as a backdrop to this scene.

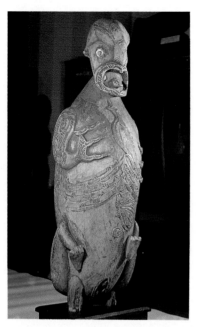

A bone chest notable for its superb sculptural form, dramatic subject, and the presence on it of the old traditional red paint.

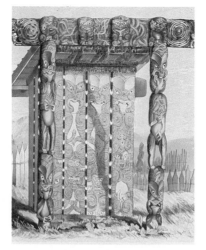

This elaborate structure is described by Angas as a 'monument to Te Whero Whero's daughter, at Raroera Pah'. He adds that it stood about four metres in height and was carved by an elderly man whose only tool was an old bayonet.

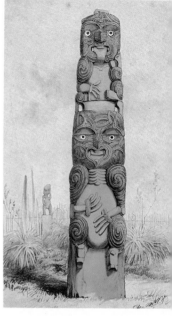

Angas described this memorial post 'colossal tiki at Raroera Pah'. Stan about 4.5 metres, its lower figure is sai represent Maui.

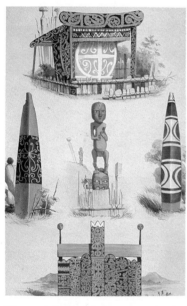

These commemorative structures sketched by Angas present us with a remarkable record of Maori ingenuity. The 'tomb' at the top of the plate is described as the 'mausoleum of E Tohi, mother of Rauparaha, on the island of Mana'. The canoe cenotaph on the right stood at a village on an island in Tory Channel. The memorial with carved tiki was at Lake Rotoaira. The other canoe cenotaph, on the right, was sketched at Te Awaiti, Cloudy Bay. The lavish use of koru-based patterns on these mid-nineteenth-century memorials indicates the historic development of this art form.

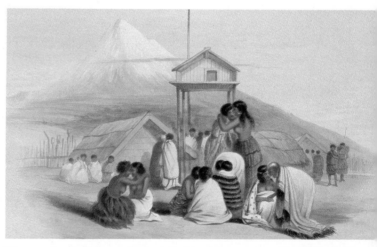

When greeting the living, or the dead, the Maori gave way to wailing and tears. Emoti welled when those of this world were met or farewelled, or when a final adieu was m: to spirits of the dead. This illustration by Angas is entitled 'a tangi (weeping) or meet of friends'. Noses are pressed in Maori greeting — the Maori did not kiss on the li but rather touched noses in affection (the hongi). A storehouse, house and Mt Egm provide a picturesque backdrop to this Taranaki scene.

It is a sad fact that the Maori art objects sketched by George French Anga in the 1840s were to be destroyed by exposure to weather and to destructiv forces. When placed under a Maori tapu restriction, houses and other object could not be touched or refurbished by anyone. They deteriorated to tota decay. So much was lost that might have been preserved, yet such was th tapu law. The popular idea of museums and general preservation of cultura materials for the benefit of posterity did not dawn in New Zealand unt late in the century. We can be thankful to those through whom, by one mean or another, much was saved. Angas with his sketchbook, families wh treasured heirlooms, and the ardent 'curio collectors' all contributed to th preservation of classic Maori cultural items.

Tattoo

Tattoo was the most personal of all arts. However, in the practice of it chiefly blood was shed from the most sacred part of the body — the head. Tattoo artists were thus regarded as highly tapu persons.

No man or woman of rank went without some tattoo adornment except in extremely rare instances when a person was too sacred to have any blood shed. The untattooed were marked as being commoners of no social standing. In fact the untattooed face was generally regarded as ugly. High-born women readily fell in love with well-tattooed men.

This indelible mark of rank was begun, with appropriate rite and ritual, at puberty. It marked the person as being of a marriageable age.

Maori tattoo was unlike most traditional tattoo in that its main lines were 'engraved' on the face with deep cuts made by miniature bone chisels. The fill-in areas were not tattooed with cuts but with the multiple pricks of small bone 'combs' that only lightly penetrated the skin surface.

The instruments of tattoo consisted of small pots of pumice or wood (some of the latter were ornately decorated) into which was placed a wetted black pigment made from burnt kauri gum, burnt vegetable caterpillars or other sooty materials. A bird bone chisel or comb set at right angles on a short wooden handle was dipped into the pigment, then a rod or stick was used to tap the head of this miniature adze, causing penetration of the skin surface. Black pigment lodged under the skin took on a bluish tinge.

An additional object was needed by the person tattooed. This was a funnel of wood (often ornately carved in the northern province) through which liquid foods could be fed to the patient after the face became so swollen that normal eating was too painful. It also kept sacred blood away from the food. The process of tattoo required many 'sessions', some of which were years apart. Partly tattooed faces were commonly seen in the nineteenth century, mainly due to the advance of Christian teaching with its opposition to this form of personal adornment.

As described in the chapter on koru in tattoo, a full male facial tattoo consisted of major spirals with smaller spirals on each side of the nose and sweeping curved lines radiating out from between the brows over the forehead and from the nose to the chin. These major patterns were cut deep, while the secondary koru patterns were lightly pricked into the skin.

Some warriors, notably those of the North Auckland region, had additional large spiral designs cut over their buttocks and long rolling patterns tattooed down the legs to the knee. When

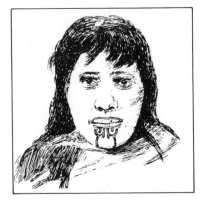

Pen sketch of a Maori woman showing typical lip tattoo. By the great student of tattoo, Major General Robley, from his book *Moko* (1896).

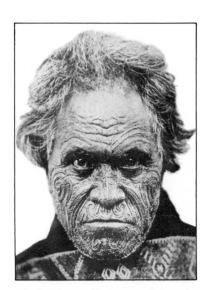

The ferocious and 'no nonsense' expression of this nineteenth-century fighting chief, Tomika-te-Mutu, is enhanced by the effect of his tattoo. Maori facial tattoo had a close relationship with certain forms of woodsculpture. The tattoo of the living and that of mummified heads had a direct influence on carving art.

Basic equipment of the tattoo artist:
The tattoist held a small handle with mounted bone cutter in his left hand. After dipping the blade into a small pot of wetted black pigment, he tapped the handle with a rounded stick held in the right hand. These light but rapid blows caused the skin to be punctured. The bone blades were of two basic types, which varied in width according to need. The chisel type made deep incisions, while the 'comb' type made multiple shallow incisions and was used for 'fill-in' tattoo. On the right is a wooden pigment pot.

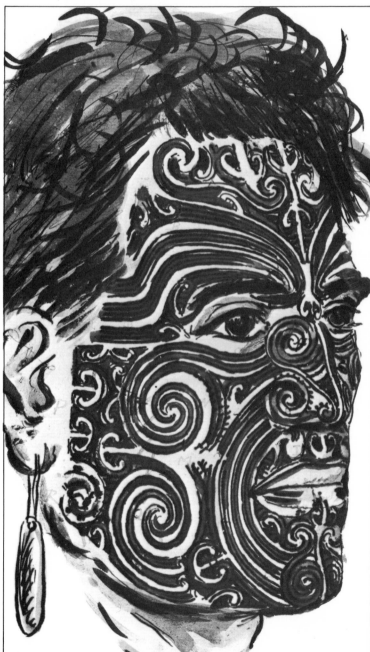

The classic pattern of Maori tattoo is well illustrated in this pen drawing by Major General H. Robley, and now in the Hawke's Bay Museum, Napier. The curved lines radiating out from a point between the eyes and from nostrils to chin, cheek spirals, and the koru-type motifs of forehead and outer cheeks was the more-or-less standard arrangement.

82

warriors went into battle, they were usually naked apart from plaited flax war belts about the waist, which were designed to hold short clubs. A cord was attached to these belts which held the penis up. It was tied to the foreskin which had been drawn over the glans — the minimum requirement of male modesty.

The tattoo of women was limited in scope. It usually consisted of deep lines cut about the lips and patterns on the chin. The lips were made blue by the comb pricking alone. Red lips on women were not admired. Some women had additional tattoo marks, such as forehead patterns or small curling motifs about the nose at the nostrils, but the basic designs were more-or-less standard.

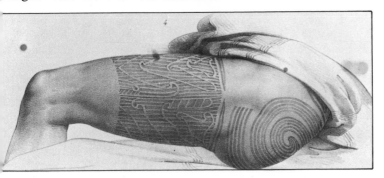

Left:
Buttock and thigh tattooing were practised mostly by the tribes of the northern region of New Zealand. This illustration is from the Atlas of the Pacific voyage of the French explorer Dumont D'Urville (1833).

Below:
Patterns of facial tattoo drawn from dried Maori heads in the collections of Major General H.G. Robley and others. They are from Robley's book *Moko or Maori Tattooing* (1896).

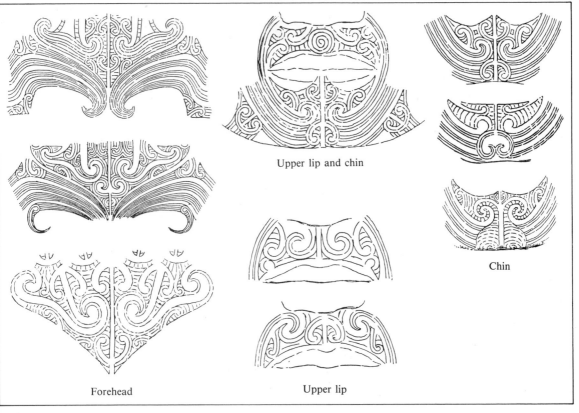

Upper lip and chin

Chin

Forehead

Upper lip

83

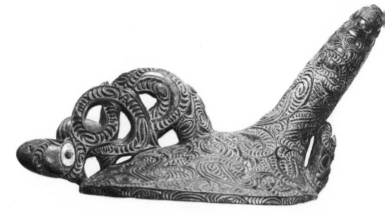

Wooden funnel of eighteenth-century origin, used to feed liquid foods to chiefs after they had been tattooed. Collection of Museum of Mankind, British Museum, London.

Combs

Combs worn by chiefly persons were highly tapu. They served as head ornaments, the means of dressing long hair, and as lice scratchers. Head lice abounded in old New Zealand.

Men of high social standing let their hair grow long. It needed careful tending before being coiled up as a topknot (tikitiki). Girls let their hair fall freely, but married women usually had their hair cropped short in the manner of the 'page boy' haircut.

Combs varied in material and form. Some were made of one piece of wood or whalebone with a small manaia head carved on the upper corner. Another type was made by lashing together wooden teeth with fine flax string. Combs were generally small in size, but some made of whale bone were as long as 25 or more centimetres.

Particular combs became family heirlooms of such mana that they became highly tapu. Open fighting did occur over rival claims to ownership of particular combs.

Combs of a variety of types were worn by Maori men. Most common in the eighteenth century was a small one of wood, with manaia head with shell eye inlay carved at the upper end *(right)*. Webster Collection, National Museum of New Zealand.

A second type of comb was composite in construction, with individual 'teeth' bound together with fine flax fibre cord. The two examples on the far right are in the National Museum of New Zealand. After W.J. Phillipps, *Maori Life and Custom,* (Wellington, 1966).

Opposite: Portrait of a Maori chief wearing a small wooden comb, from an engraved plate in Captain Cook's first voyage journal. The engraving is from a drawing by Sydney Parkinson, artist with the expedition.

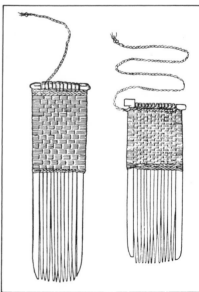

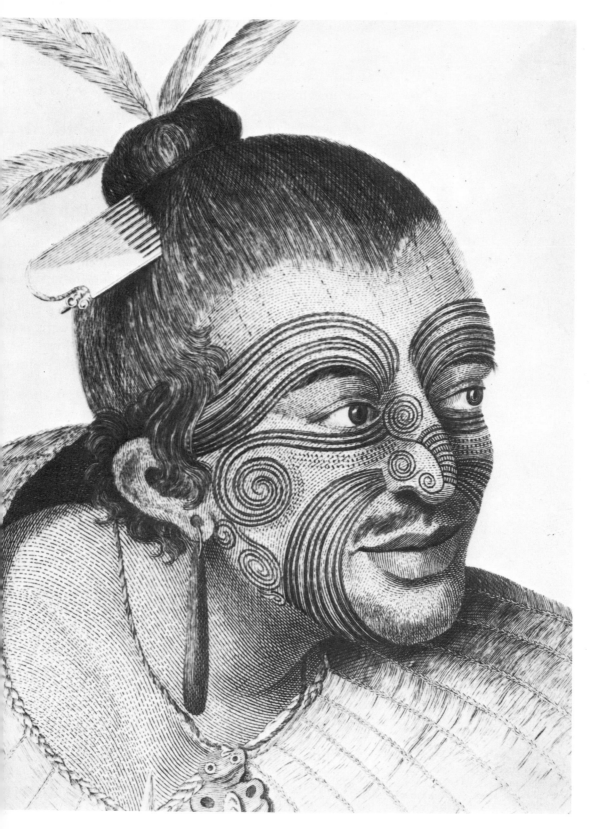

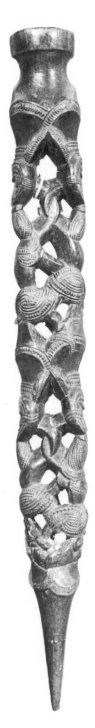

Weaving pegs (turuturu) were set in the earth to hold the warp elements of a garment. The peg on the right hand side had a ritual significance. This fine example is in the National Museum of New Zealand.

Garments

The pre-European Maori wore two basic garments — a waist mat and a cloak. The clothes of commoners were of plain manufacture, while those of people of rank were superior, sometimes being decorated with feathers or dyed tags and decorated borders.

Children ran more-or-less naked until puberty, being dressed only for special events. In general the Maori was not much interested in clothing other than as weather or ceremonial occasion required.

As far as bodily exposure was concerned the only rule of modesty was that mature adults keep their genitals covered. To expose sexual organs indiscriminately was considered a disgraceful act. Women wore no garments above their waists except for cloaks when they were needed for warmth or ornament. Some working dress consisted of nothing more than belts with leaves thrust under them.

The manufacture of superior garments required highly specialised skills. Common rain capes and old waist mats served those of high and low rank for everyday toil or travel. Fine garments were made for special occasions and for particular people.

Chiefs and commoners usually went barefoot, using rough sandals on journeys over rough country.

Most sketches, paintings, and photographs of nineteenth-century chiefs show them in post-missionary styles of Maori dress. The old lithographs of Maori men and women, such as the drawing of dancers on the deck of Dumont D'urville's ship, *L'Astrolabe,* provide a truer picture of the ordinary dress of the time.

Ornamented Cloaks

The Polynesians who settled New Zealand had no weaving looms. In their tropical islands, bark cloth called 'tapa' was made by beating flat the inner bark of the paper mulberry and certain other trees. Tapa was used for many purposes, especially clothing and bed coverings.

The climate of New Zealand was too cool for the paper mulberry to flourish, and the wet climate would have rendered tapa — which is a paper — unsuitable as clothing.

The fibres of flax *(Phormium tenax),* which grew almost everywhere in abundance, yielded an exceptional substitute material that met all clothing needs of the Maori.

The problem of converting fibres into garments without use of a loom was solved by applying an old Polynesian tying technique used in forming fishtraps. This consisted of bringing together small bundles of fibres by a twining process called

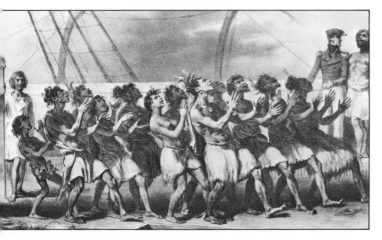

finger weaving'. The fibres were first rolled with the palm of the hand to form cords, then these were tied together by a dextrous twisting process better illustrated than described.

The equipment used in this simple 'weaving' was a pair of sticks or pegs thrust into the ground a short distance apart. The weft fibres of the garment (or taniko border) to be formed were stretched from peg to peg. Then the downward or warp elements were attached and twisted about the hanging cords. Blanket-like textiles so formed were strong and served as warm garments.

Superior cloaks were ornamented with feathers or tags, which were worked into the textile as it was being made. The subject of Maori clothing has been described in detail in several books, notably S.M. Mead's *Traditional Maori Clothing* (Wellington, 1969).

Taniko Cloak Borders

Flax fibre was also used in the weaving of decorative cloak borders called taniko. These were formed by a close knotting process which has been described, and it is still practised today. Modern taniko work is conspicuous in the dress of concert party performers.

Eighteenth- and nineteenth-century taniko is usually quite beautiful. The patterns were composed of triangles, zigzags, lozenges, and diamond motifs. Some designs are simple while others are complex. The red, orange, and yellow fibre colours of taniko were derived from vegetable dyes. Black fibres were dyed by immersion in swamp mud.

An interesting feature of many nineteenth-century taniko borders is that they were oversewn with European needle and thread. The threads used were bright cotton fibres drawn from introduced cloth. In time manufactured chemical dyes replaced the old vegetable dyes that had produced the soft, subdued colours of traditional taniko.

The making of fine garments was a serious occupation among women, particularly those of the chiefly class, as it demonstrated their artistry. The lower order of women were generally too much engaged in drudgery to have the leisure for such pursuits. Fine cloaks served as a kind of currency in gift exchange, payment of carvers, and in honouring important guests.

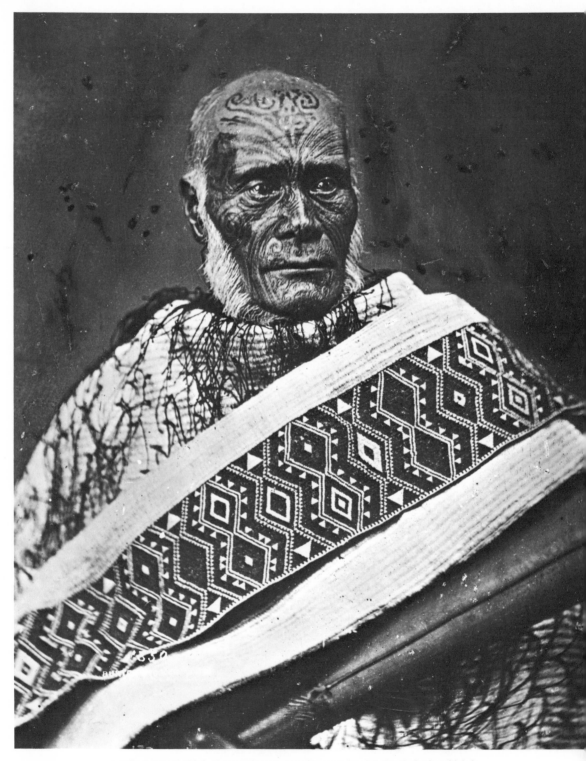

A fully tattooed chief, Ihaka Whanga, wearing a taniko bordered cloak, which is inverted for the convenience of the Victorian photographer. Such borders were worn at the base of the cloak, with an occasional narrow band of taniko running up the vertical edges.

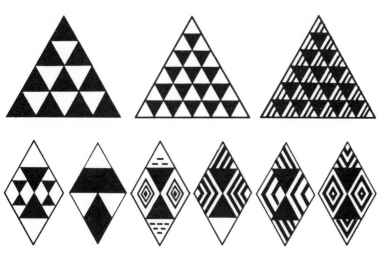

Taniko patterns have a rectilinear character due to the technique by which they are manufactured. Some primary triangle, lozenge and diamond motifs are illustrated in these line drawings. After W.J. Phillipps, *Maori Rafter and Taniko Designs*, (Wellington, 1960).

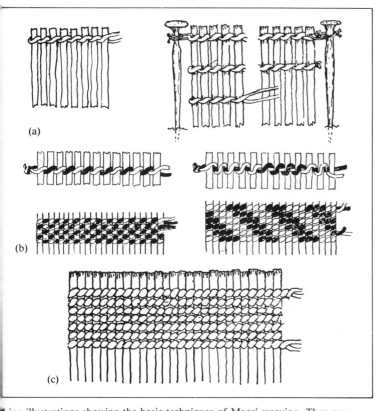

Line illustrations showing the basic techniques of Maori weaving. They are:
(a) method of single-pair twining between pegs
(b) the so-called 'bird cage' twine using half and full turn of elements, neutral and black-dyed
(c) method of working 'close' single-pair twining.

After Te Rangi Hiroa (Sir George Buck), *The Coming of the Maori,* (Wellington, 1949).

Weapons as Regalia

Maori weapons were treasured by their owners. They served in battle and were also personal regalia. A man of rank was not fully dressed without a weapon in hand. Also weapons were essential to effective oratory. As a chief spoke on the marae or elsewhere he emphasised points of his speech with flourishes of a short or long club. No warrior moved abroad without his weapons for the simple reason that sudden attack was the rule. Even when he slept they were within reach.

The weapon of the commoner was often a short spear pointed at both ends. The taiaha was also popular yet was more typically the weapon of chiefs. Fully equipped warriors carried both short and long clubs, the former being worn thrust into a plaited waist belt while the latter was always carried in the hand.

Short clubs were made of wood, whalebone, or stone; the most valued being those of greenstone. Long clubs were of three forms: the taiaha, tewhatewha, and pouwhenua. The various weapon types are illustrated.

Maori weapons, excepting short and long spears or bludgeons, were most deadly when used in slicing or thrusting movements. The edge of the flat blade was aimed at a vulnerable bodily part, such as at the temple or below the ribs.

Long clubs were swung with two hands grasping the shaft near the lower, pointed part. Point ends were used for jabbing, but it was the edge of the flat blade that was the deadliest part.

Short patu were often sharp at their forward edge and were thus most effectively used with forward thrusting, jabbing, or swinging blows. These short weapons that we call 'clubs' are not true clubs. The only Maori club was a bludgeon which made direct mashing blows. This type of weapon was named patuki and is among the rarest of weapons. A feature of patuki was their extensively decorated surfaces, often with incised koru.

Maori weapons are notable for their fine sculptural form. They were designed for close hand-to-hand combat, and no other stone-age war implements surpassed them in deadly effectiveness.

Long war spears were used to thrust through palisades.

A kind of short spear was thrown by a whiplash (kotaha). This apparatus consisted of a short stick with an attached cord which was tied about the spear with a slip knot. The spear was thrust in to the ground at an angle, then projected by a sudden jerk of the whiplash stick. Kotaha are of interest as art objects because of the remarkable figures carved on their upper ends.

A particular curved weapon called hoeroa was made from the jawbone of a whale. Its actual use is unknown. They may have served as ceremonial batons of authority rather than as

Opposite: Short club of wahaika type, 37 cm in length, which illustrates the occasional practice of decorating parts of grip and blade of such weapons. Maori weapons usually had a minimum of surface decoration. National Museum of New Zealand.

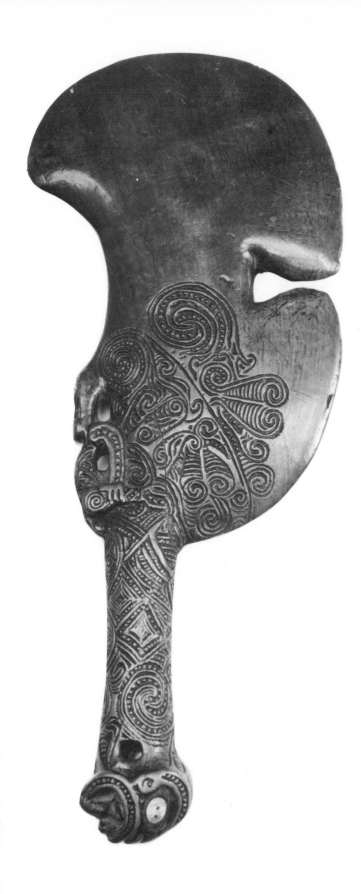

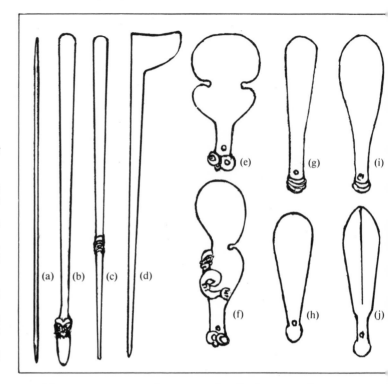

Line drawing of the basic weapon types of the Classic Maori:

(a) common spear (tao)

(b) long club of taiaha type (fringes of dog hair and collar of red parrot feathers were attached at lower end)

(c) long club of pouwhenua type with sharp lower end

(d) long club of tewhatewha type (the axe-like projection at upper end was to add weight to the opposite striking edge)

(e) short club of kotiate type

(f) short club of wahaika type with small image above grip

(g) short club of dense stone (patu onewa)

(h) short club of greenstone (patu pounamu or mere)

(i) short club of whale bone (patu paraora)

(j) wooden bludgeon (patuki).

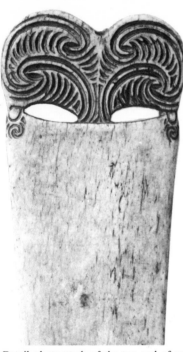

Detail photograph of the top end of an unusual whalebone 'club'. Some say it is a weapon form, while others claim it was used as a dance implement, or was the baton of a chiefly captain of a war canoe. The high stylisation of a face carved in bone is of special interest.

working weapons, such as one the fugleman of a war canoe might flourish as he chanted rhythmically to urge on a crew of paddlers. The artistic feature of this odd artefact is the highly stylised 'face' carved at one end.

Ceremonial Batons

The various forms of batons served as symbols of chiefly authority. They usually had a tiki or other motif carved above their handles.

The most remarkable baton of authority is a form of ceremonial adze called toki-pou-tangata. This consisted of an ornate wooden handle with a long, narrow jade blade, which often had a lashing hole at its butt end. The carved design of the upper part of the wooden handle varied in design, but was typically an out-turned tiki, its lips interlocking with those of a manaia. A mask was usually carved at the lower end of the handle.

The use of the toki-pou-tangata is not exactly known. That it marked a man of authoritative rank is certain. Some believe it was a baton of war used to kill distinguished prisoners. The weapon used to kill a captive chief was an important matter to both the despatcher and the man who died. A chief taken prisoner might request, before his execution, that he be slain by a certain, famed weapon. To be struck down by a special patu was a point of honour. Of course to be killed was far

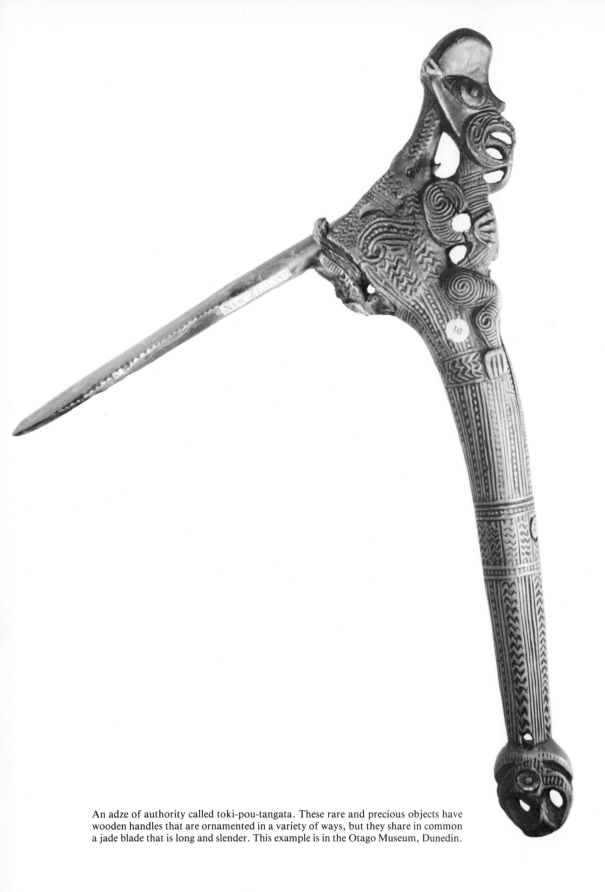

An adze of authority called toki-pou-tangata. These rare and precious objects have wooden handles that are ornamented in a variety of ways, but they share in common a jade blade that is long and slender. This example is in the Otago Museum, Dunedin.

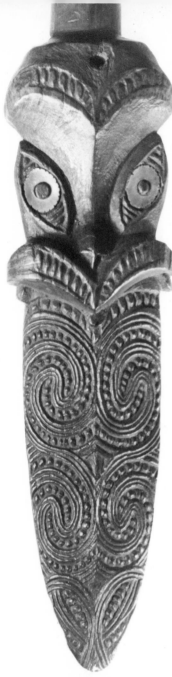

preferable to being taken into slavery. Slavery was the ultimate humiliation for a noble person. Those taken into slavery were regarded as dead by their kinsfolk. Even if they escaped or were released and returned to their people, they were disregarded and treated with contempt.

Treasure Boxes

Treasure boxes called wakahuia were small wooden boxes used to store personal valuables. Maori houses had neither cupboards nor drawers so containers were necessary. These boxes varied in size from about 25 to 90 centimetres in length, were usually much decorated, and are superb examples of the woodcarver's craft. The variety of design is the most remarkable feature.

Wakahuia illustrate the diversity of regional carving styles and a large portion of those preserved date from early periods. As with hei-tiki, these boxes were sought by early visitors as attractive, portable 'curios'. Hundreds of them were carried away from New Zealand by early travellers, some by Captain Cook and his crews. Fortunately many of the best wakahuia were returned to New Zealand in the W.O. Oldman and K.A. Webster collections and are now to be viewed in museums.

'Wakahuia' is a composite word: 'waka' means a canoe or vessel while 'huia' is a thing prized. The association of wakahuia with the bird 'huia' (whose white-tipped, black tail feathers were so highly valued) and the inclusion of rare feathers in these storage boxes, gave rise to calling them 'feather boxes', but many prized objects, particularly jade ornaments, were kept in them. The larger boxes were used to store treasured objects such as combs and jade clubs.

Wakahuia were carved in many shapes. The single common feature of them was an inset lid which was fitted in a number of ways, some methods being quite ingenious.

Many of the boxes were designed so that cords could be tied to their projecting ends then passed through holes in their lids. They were then suspended from rafters or walls. In most traditional Maori houses the rafters were within easy reach. One remarkable feature of a number of boxes is that the suspension string or cord passes from box to lid in such a way that the lid is drawn closed when the box is hung up.

Wakahuia were usually carved on all sides and on the ends. The most elaborate decoration usually appeared on the underside as the boxes were mostly viewed from below. Their lids were also frequently elaborate in their decorations.

Some wakahuia were of a canoe hull form with tiki heads projecting out from each end, similar to the heads seen on the prows of certain canoes. The 'bodies' of these heads were, in some designs, placed on the underside of the box.

Base end of a long club of taiaha type shows in detail the arrangement of the face with a long projecting tongue. Such clubs had this double or 'Janus' head, which is the same on both sides. The killing end was the flat, spatulate blade edge of the upper part, although this 'tongue' projection was used in prodding movements in the rapid sparring of warriors and could disable an opponent. This taiaha was collected on a visit by Captain Cook to New Zealand in the late eighteenth century and is in the Cambridge University Museum of Archaeology and Ethnology.

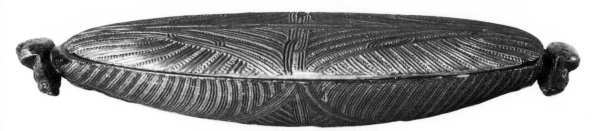

Treasure boxes (wakahuia) are of varied shapes and have carved designs of many styles, which convey information as to their origin. North Auckland boxes are typically of an oblong flattish form, while those of the East Coast-Bay of Plenty region have often carved in a canoe-like form. The box above is of the latter type.

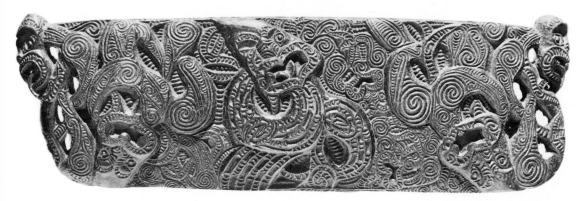

An underside view of a North Auckland treasure box, illustrating the northern regional style. This example is in the W.O. Oldman Collection, National Museum of New Zealand.

Musical Instruments

Musical instruments were personal possessions played as occasion required. Many had holes carved on them so that they could be suspended from the necks of their owners.

Trumpets of triton shell, wooden war trumpets, war gongs, various whistles, and 'bull roarers' were used to create sounds for particular occasions, but these were not for individual use.

There were several types of flutes. Many of them seen in museum collections are of notable artistic beauty.

Flutes were made in both long and short forms. The long flute, putorino, varied in length from approximately 23 to 56 centimetres. They were formed from two wooden halves lashed together. Their decoration was varied. Some had a tiki head at the top, at times with a manaia linked to its lips. The sound hole was occasionally made in the form of a tiki mask — the hole representing the mouth of the tiki.

The short flutes were of a stumpy form carved from one piece of wood and hollowed through the centre. Three or more finger stops were drilled in the body of these flutes. Some were highly ornate.

The sound of Maori flutes ranged over little more than two tones. They were very often used as instruments of courtship, as in the well-known story of Hinemoa and Tutanekai.

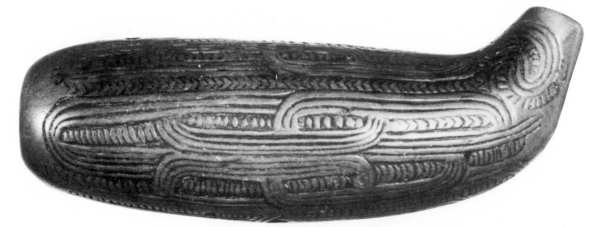

Small wooden whistle (nguru) with decorated surface. K.A. Webster Collection National Museum of New Zealand.

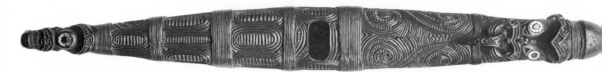

A long flute (putorino), 38 cm in length. Flutes of this type were formed by binding hollowed-out front and back with split kiekie vine. This example is from the Museum of Mankind, British Museum, London.

To repeat this famous tale, Hinemoa, a high-born maiden, lived at her village on the shores of Lake Rotorua. She was guarded jealously by her relations who wanted her to marry and make the best tribal alliance possible; but she had her heart set on one man. Tutanekai was a chief who lived on Mokoia Island, far out on the lake. He was not acceptable to Hinemoa's kinsfolk so she was forbidden to go to him. However, each evening she listened to the plaintive strains of his flute drifting to her from the island.

Hinemoa's relations, fearing she would take a canoe to go to her lover, always drew them well up onto the shore. Yet love always finds a way. Hinemoa gathered several hollow gourds, tied them together, then in the darkness of the night used them as floats to help her swim to Tutanekai. These lovers slept together and so, by Maori lore, became man and wife. To this day, their descendants dwell in the vicinity of Lake Rotorua. The Tama-te-Kapua meeting house at Ohinemutu has a carved panel which depicts Tutanekai playing his flute.

Whistles, or nguru, carved from one piece of wood were sometimes decorated with designs. These, and other small musical instruments, were objects which varied greatly in both design and decoration.

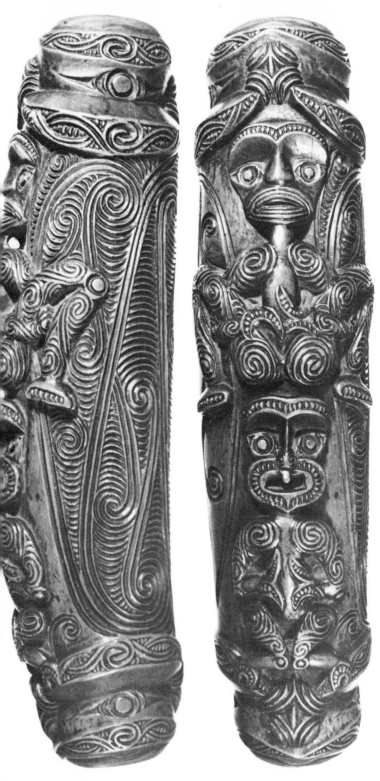

Two views of a short flute (koauau), 20 cm in length. W.O. Oldman Collection, National Museum of New Zealand.

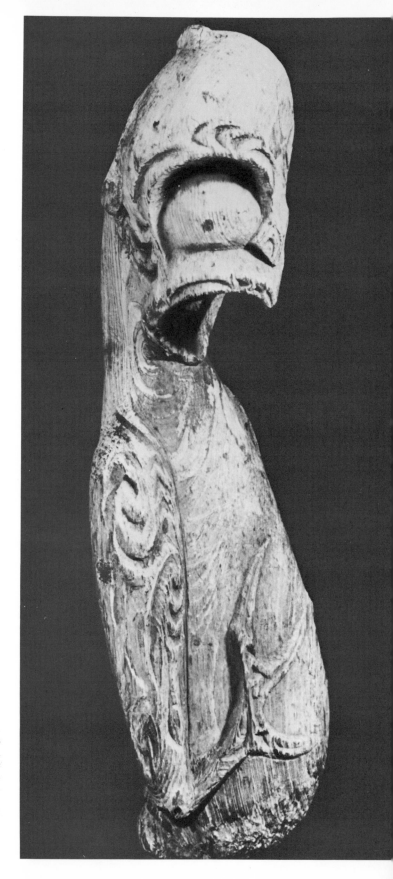

A small bone chest, standing 45.7 cm high, designed to hold a few bones such as vertebrae. The figure is that of a birdman with clawed hands and beaked mouth. The souls of the dead were thought to use birds as carriers or vehicles, a brief that seems to have inspired this type of symbolism. This box is in the National Museum of New Zealand.

Particular Sacred Objects of the Maori

The Classic Maori had many religious concepts which seem to be akin to modern scientific ideas. Their beliefs that time reached over eons, that life forms evolved, and that animate and inanimate forms of nature had a kind of life force are remarkable.

Maori Religion and Visual Art

All things made by the traditional Maori had an individual 'spirit', an indwelling 'something', which made them untouchable to those of a rank below that of their owners.

Those of higher rank considered it a pollution to touch or use anything that belonged to persons inferior to themselves. This was the basic 'law'. For a person of inferior birth to touch the possessions of the high-born was usually a sentence of death.

Certain objects were so sacred (tapu) that it was extremely dangerous for any unauthorised person even to look at them. They were things made to be handled only by qualified priests. The aura or sacred power (mana) of such objects was so intense that even to be near them could be harmful.

Two classes of such objects of art interest were the godsticks and bone chests.

Today we seem not to be subject to the same tapu, yet to use these forms as tourist curios is inappropriate. Let good taste and respect prevail in any handling of Maori art materials.

Godsticks

Godsticks (tiki wananga) were of simple form. They were usually no more than a mask set at the top of a peg. A head plus arms, or a whole tiki were unusual. Below the ornamented part, cord lashings and red feathers were added for ritual purposes. The addition of sacred cordage and feathers made the godstick 'alive'. Then the spirit of the god represented entered into them.

The Reverend Richard Taylor, an enlightened missionary of the early nineteenth century, heard of the existence of

According to ancient Polynesian belief, the spirits of the dead departed from the northwest parts of various islands to return to the spirit land of their ancestors. The Maori placed such a departure point at Te Reinga at the northern tip of the North Island. Spirits were said to climb down the roots of pohutukawa trees, then make their way to the Maori Underworld. This study is from W. Dittmer's *Te Tohunga* (1907)

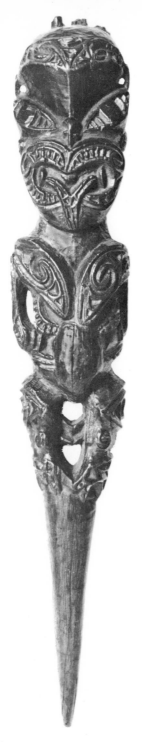

A godstick formed by a carved wood tiki set above pointed peg base, which allowed it to be thrust into the earth. This unusual specimen stands 35. 5 cm in height. It was collected on one of Captain Cook's voyages and is in the K.A. Webster Collection, National Museum of New Zealand.

This imaginative drawing by W. Dittmer, from his book *Te Tohunga* (1907), show a priest addressing a godstick, which would have served as the vehicle of the spiri the priest was endeavouring to contact. Gods and other spirits were invoked by the chants of qualified men.

godsticks. Most had been hidden or cast away by Christian converts, but because of his interest, he persuaded some Maori friends to bring a few of them to him. Thus some of these rare images were preserved.

When used by a priest, a godstick was either thrust into the ground or held in the hand. At times the priest tied a string to the god image, which he pulled gently to gain the attention of the god. Requests were made of the deity concerned to aid some plan or otherwise to advance community welfare.

Bone Chests

Bone chests (waka tupapaku) were wooden coffins made to contain bones. They varied in design. Those seen in museums are mostly from the northern regions about Auckland. They were carved from a single piece of wood, then fitted with a kind of slab door at the back.

Maori burial practices differed according to the rank of the dead person. The bodies of commoners were generally disposed of in a rather casual way, being mourned over only by close kin. The burial of a person of rank involved a whole tribe or sub-tribe.

The disposal of the body of chiefly persons had two phases. First the corpse was buried or left in a hidden place, then after a year or two the bones were gathered for a final burial. During a second 'burial' the bones were scraped of any adhering tissue, oiled, and painted with red ochre. The final disposal of the bones was the more important of the two mourning occasions as it was the event of the final departure of the spirit to the distant land of the Maori dead via Te Reinga. For the second time, women lacerated their faces and bodies with stone flakes, shells, or shark's teeth in a dramatic show of flowing blood. The men folk often taunted one another and thrust about with spears. This was to honour the departing spirits.

Bone chests were both large and small. Some contained only a few bones or a skull. The boxes with the bones were usually secreted in caves or other hidden places.

Some bone chests were designed with a peg at the base so that they would stand upright in the earth of a cave. Dampness often rotted away this part, and the box would fall over, to decay on one side.

The design of bone chests is typically of a basic tiki form and usually of female sex. Small birth figures occasionally appear on them. Bird-like eyes, beaked lips, and three-fingered clawed hands support the notion of birds acting as vehicles and guardians of spirits. Some boxes have the webbed feet of seabirds which adds to this general bird association.

Many boxes have a canoe form even displaying a keel ridge down the front of the tiki, which relates to the idea of the soul of the dead travelling over the sea back to ancient Hawaiki — the legendary homeland of the Maori. Cut sections of canoes were sometimes used as bone chests, with the same idea of sea travel for the spirit.

The representation of a female tiki as the subject of many chests may be due to the association of the soul with the Goddess of Death — Hine-nui-te-Po — who crushed Maui to extinction when he tried to secure immortality for mankind

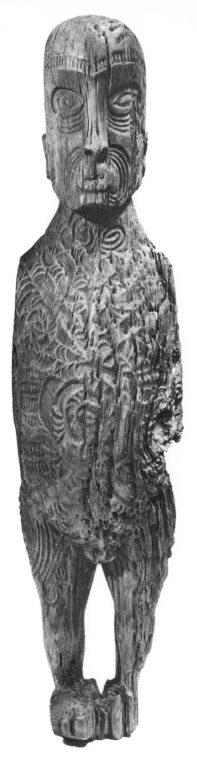

Bone chest in the form of a standing tiki 93 cm in height. This chest, which was taken to England in the early nineteenth century, is now in the Museum of Mankind, British Museum, London.

101

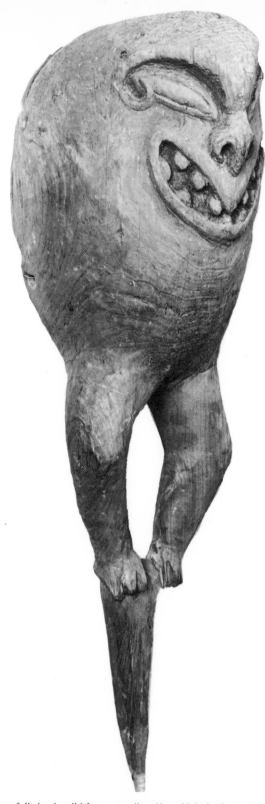

A bone chest of distinctive tiki form, standing 60 cm high, in the Auckland Museum. It was found in a burial cave near the entrance of Whangaparoa Harbour, North Auckland. The box was designed to contain a human skull.

y crawling towards her heart via her vagina while she slept.
he awoke when his companions, the birds, laughed at the sight
f this act, and so the great demigod died. Associated figures
nay represent Maui, yet like so many symbols of Maori art
o one knows exactly what they mean.

eneaological Staves

hese wooden sticks, set with knobs running down their shafts
nd sometimes tipped with a tiki head, were used as an aid
o genealogical recitation. These sticks, called whakapapa
akau, are now rare. They varied in length, but averaged just
ver a metre.

How they were used is not precisely known, yet it seems they
ere to help recitations of the family tribal genealogical
ecords. The knobs indicated the names of successive ancestors
r groups of ancestors.

ites

ites were used for play by children and adults. Some were
sed in ritualistic magic, when priests flew them for divination
urposes. From their movements, those initiated in this art
ould read omens. These influenced tribal action, following
he advice of the priests concerned.

Kites were used at many levels in Maori
society. Children and adults flew them for
amusement, but large, carefully made kites
were also used in religious ritual, when
priests divined the future and sought omens
from the kite's gyrations. This kite, made
in the nineteenth century, is in the Museum
of Mankind, British Museum, London.

Monuments

Monuments or cenotaphs were erected to the memory o
famous people and to commemorate special events. Sometime
the bones of the dead were placed with or near these markers
More often they were hidden to avoid vengeful enemie
desecrating the bones.

At times sections of canoe hulls were placed vertically in th
earth as memorials. Some were painted over with koru-typ
patterns such as those seen in the lithographic plates made b
George French Angas. In the nineteenth century, monument
and cenotaphs became increasingly popular as the forme
practice of hiding the burial place of the deceased declined
Christian teachings were a part of this change of attitude.

Some posts with tiki carved on them were set up as marker
to commemorate a memorable event. Also, there wer
territorial boundary markers (rahui) which resemble thes
commemorative carvings.